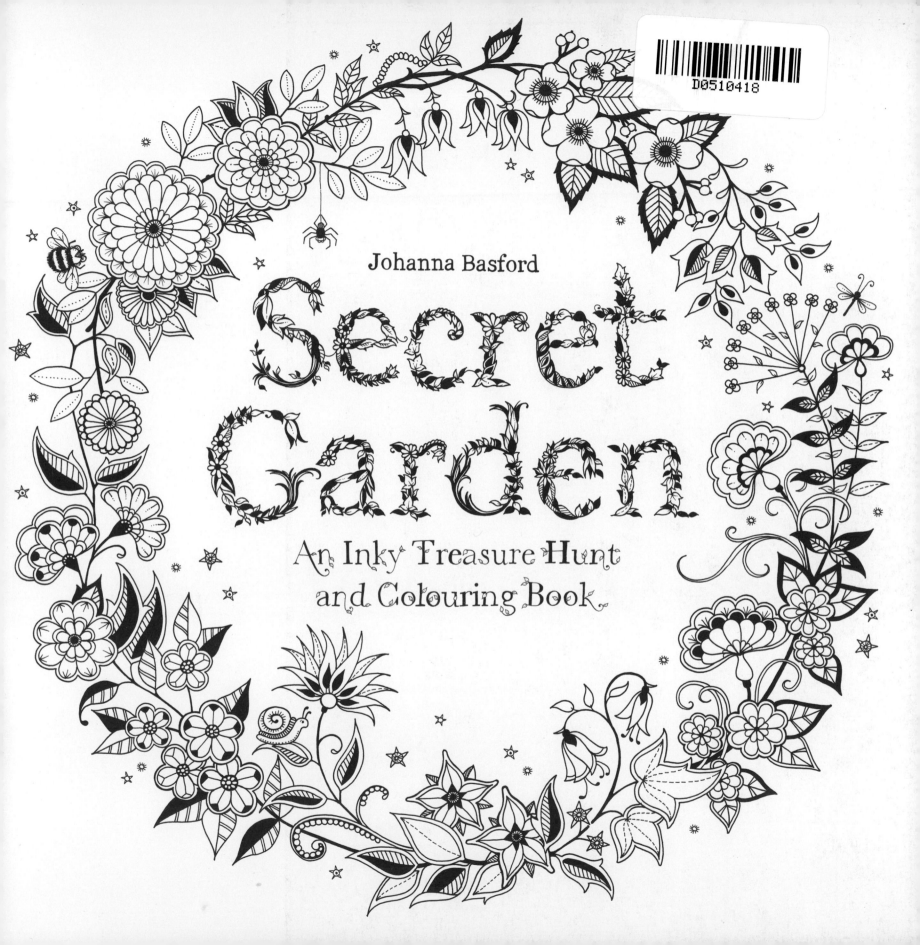

Johanna Basford

Secret Garden

An Inky Treasure Hunt and Colouring Book

LAURENCE KING

Published in 2013 by
Laurence King Publishing Ltd
361-373 City Road
London EC1V 1LR
Tel: +44 20 7841 6900
Fax: +44 20 7841 6910
email: enquiries@laurenceking.com
www.laurenceking.com

Reprinted 2013 (five times), 2014 (six times), 2015 (eighteen times)

A catalogue record for this book is available
from the British Library.

ISBN 13: 978 1 78067 106 2

Design: Jason Ribeiro, Johanna Basford

Printed in The Netherlands

This book belongs to

Hidden inside this book there are...

3 chrysalises

8 spiders

9 dragonflies

14 caterpillars

20 song birds

1 treasure chest

1 hedgehog

1 cat

16 bees

1 squirrel

5 moths

1 padlock

2 hummingbirds

63 beetles

2 frogs

1 shark

4 keys

6 flying beetles

16 ladybirds

5 wasps

13 owls

1 message in a bottle

16 snails

116 butterflies

11 ants

7 slugs

1 peacock

27 fish

3 mice

...Plus a few butterflies and beetles where only a leg or a wing made it onto the page!

At the end of the book is a key that tells exactly what can be found in each picture.

Welcome to my inky world of secret gardens!

Inside this book you'll find a magical black and white wonderland full of fantastical flowers and curious plants.

There are pictures to colour in, mazes to solve, patterns to complete and lots of space for you to add your own inky drawings. Use felt tip pens to add a splash of colour or a black pen with a fine nib to create your own doodles and details.

Peppered throughout the pages you'll spot half hidden creepy crawlies and curious little creatures. Search between the blossoms to find the bumble bees, butterflies and birds that are hidden within.

Use the Secret Garden List to help you keep track of all the things you have found on the inky treasure hunt so far.

Good luck!

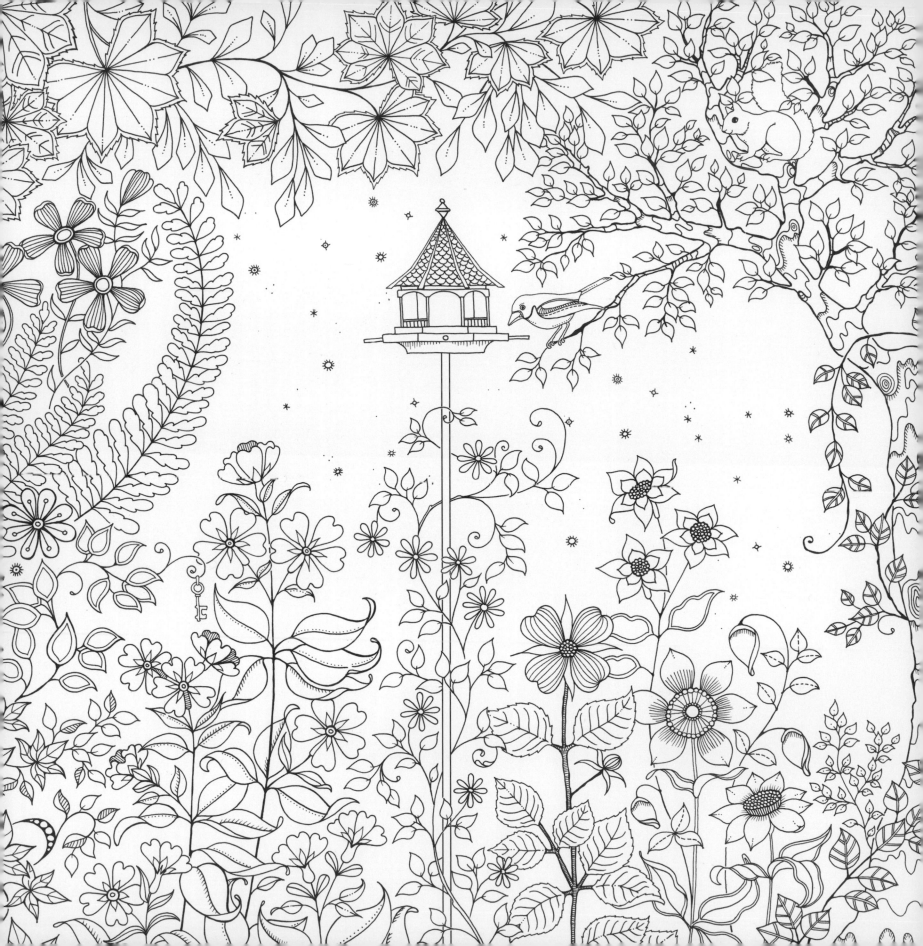

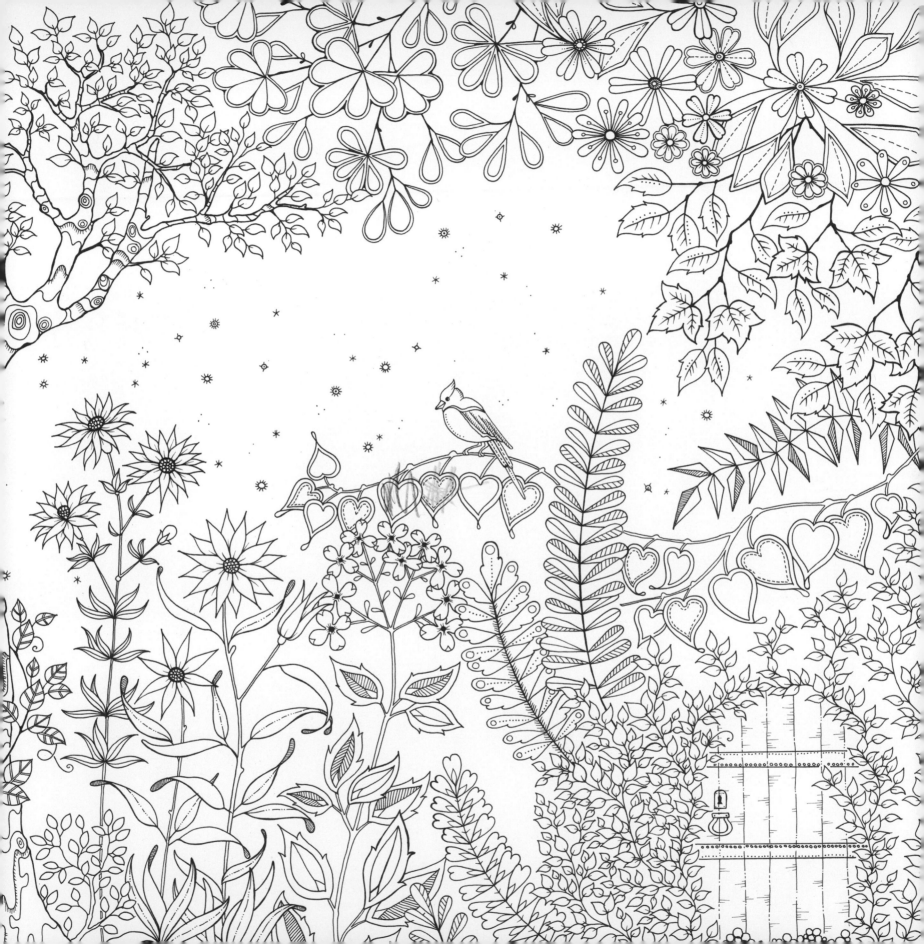

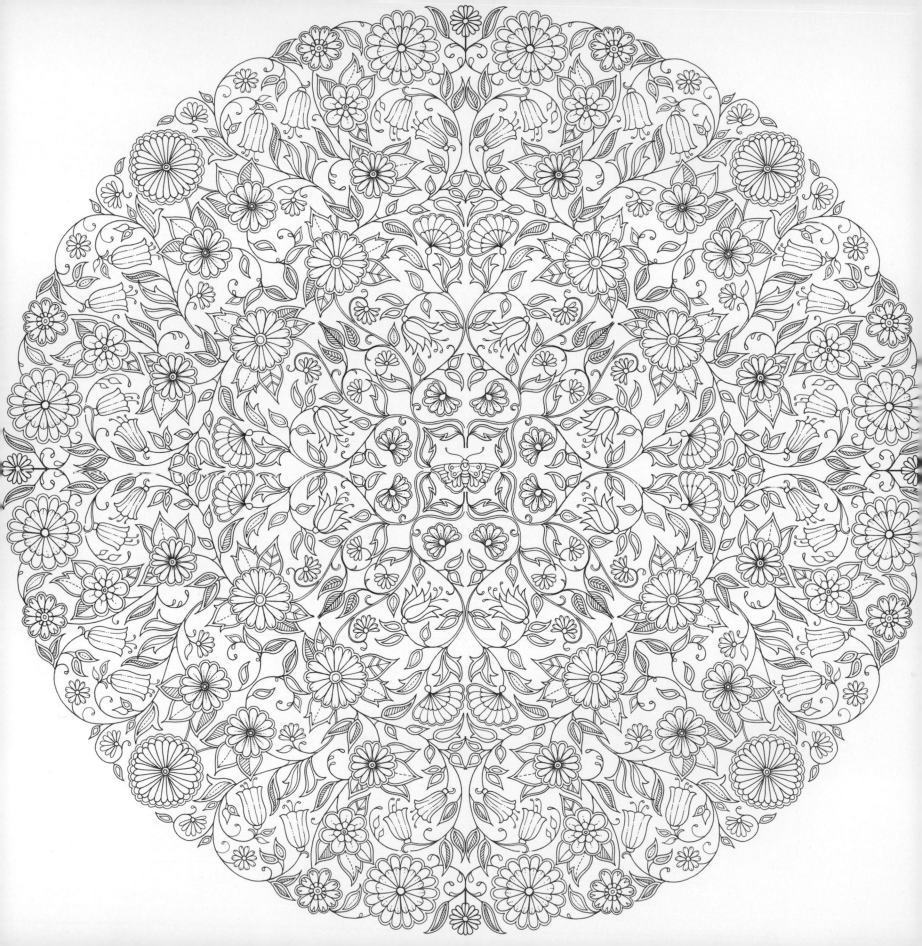

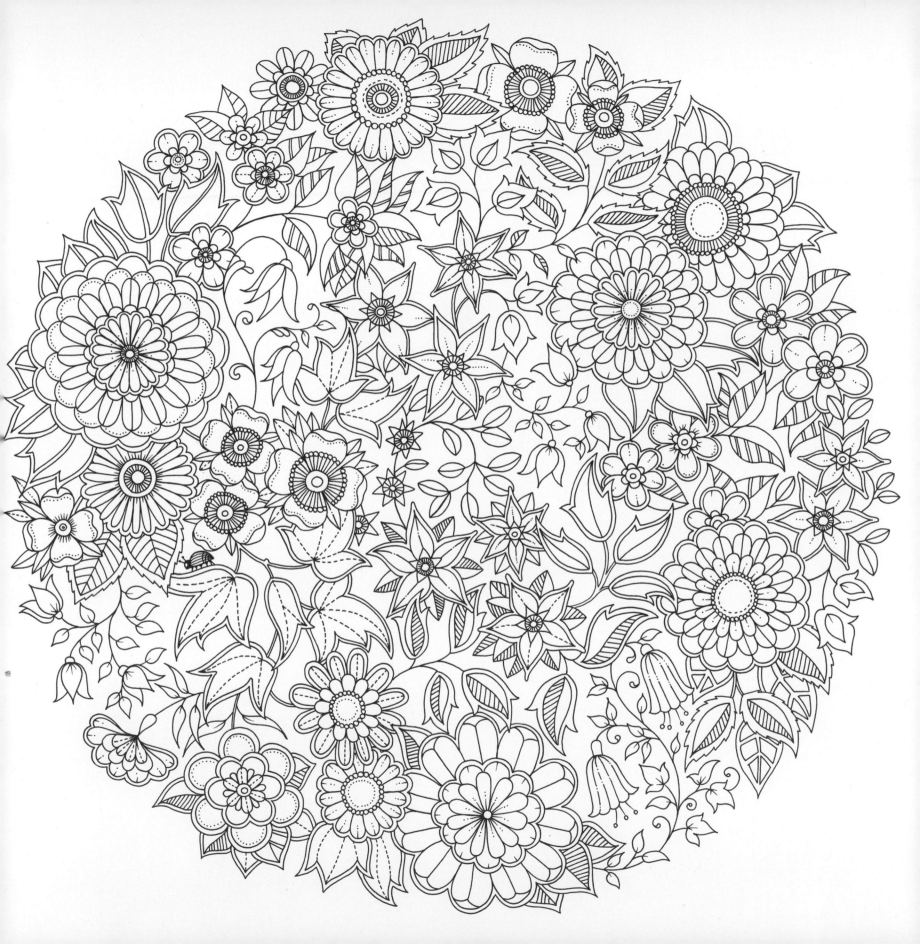

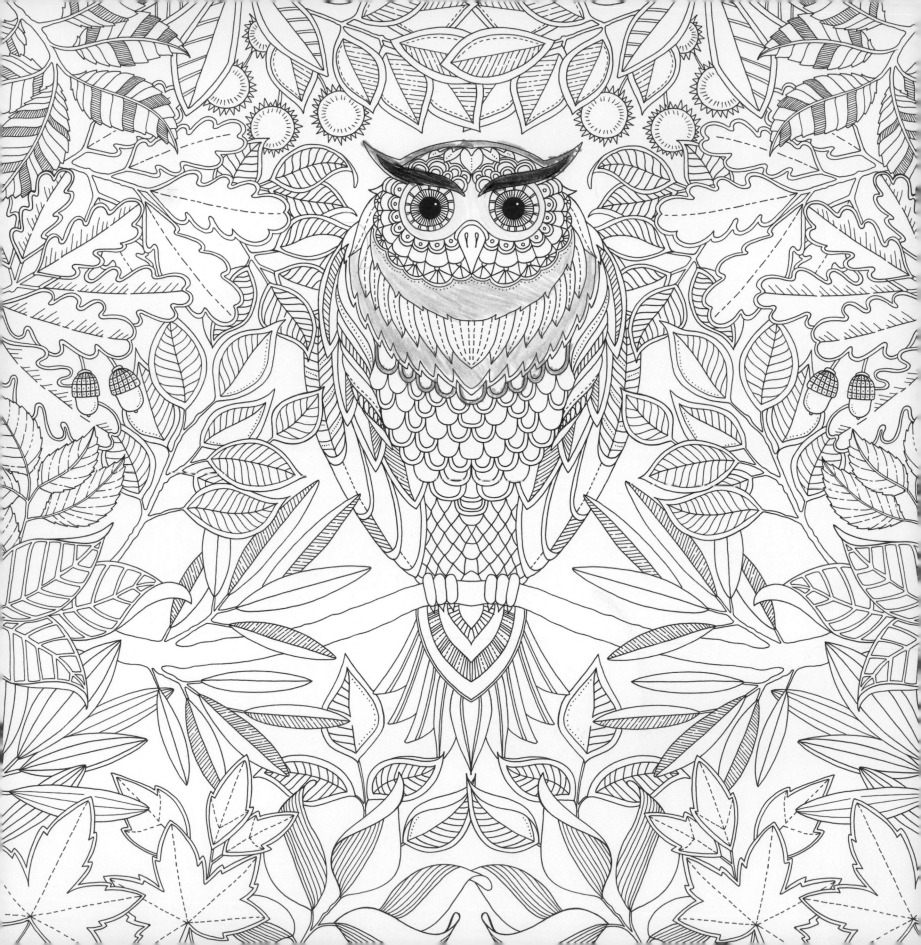

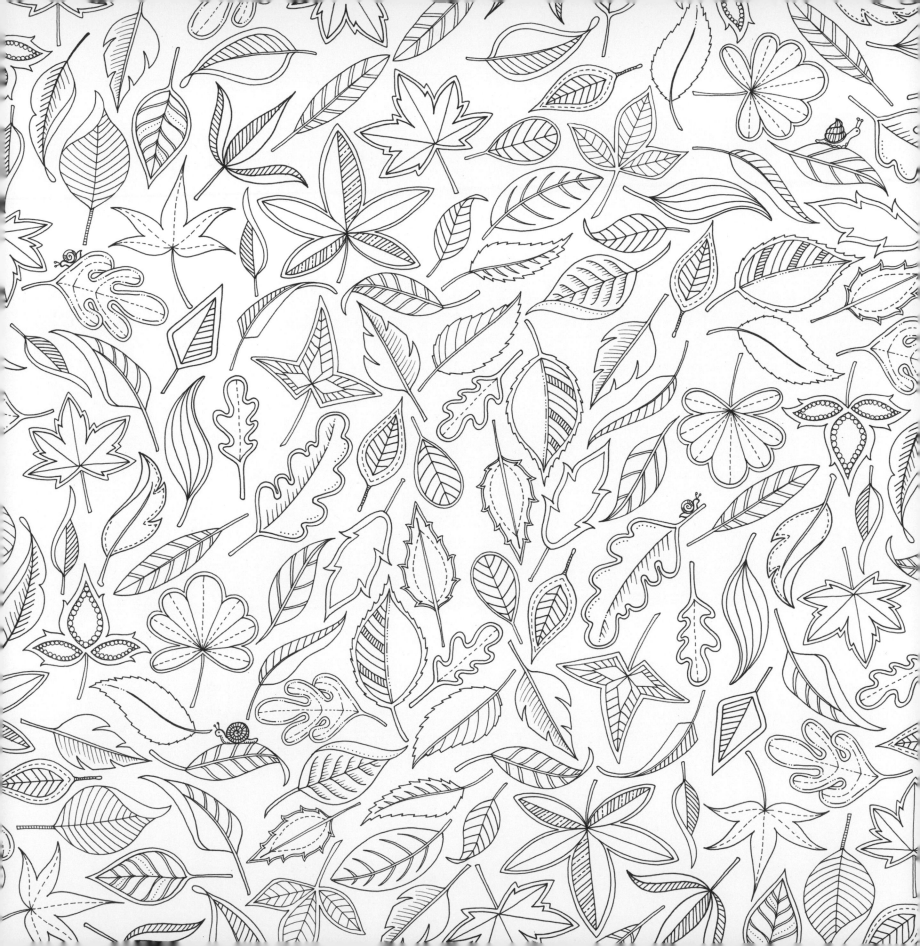

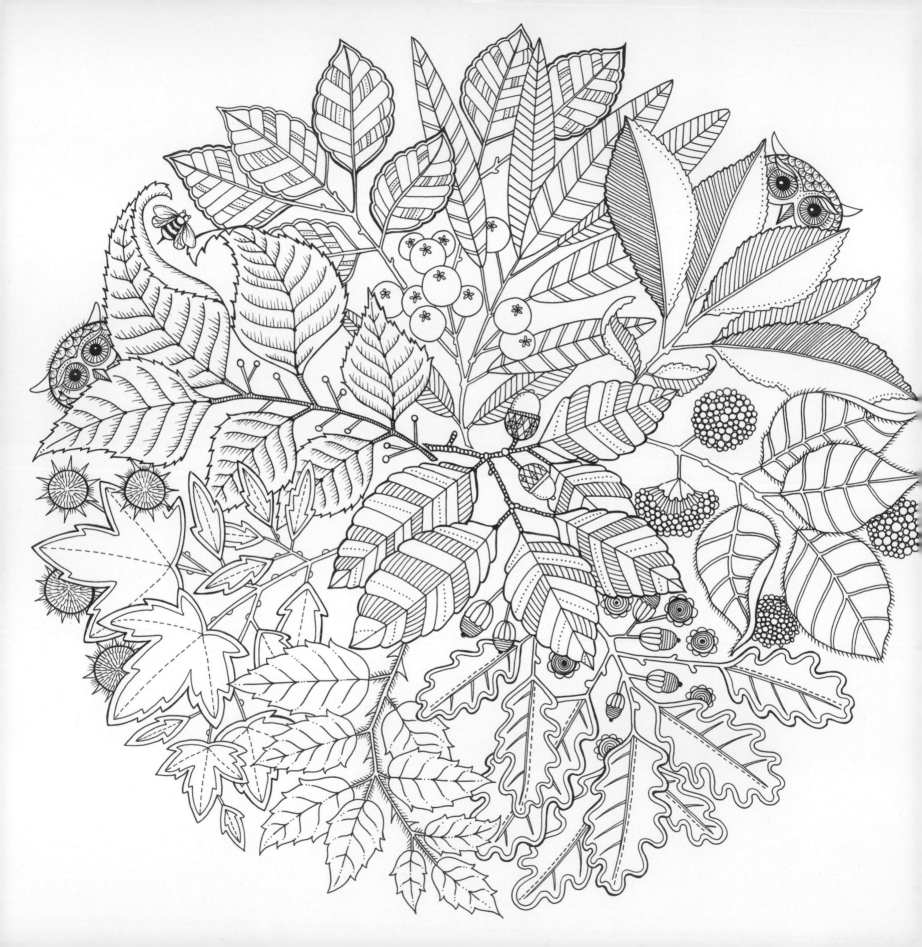

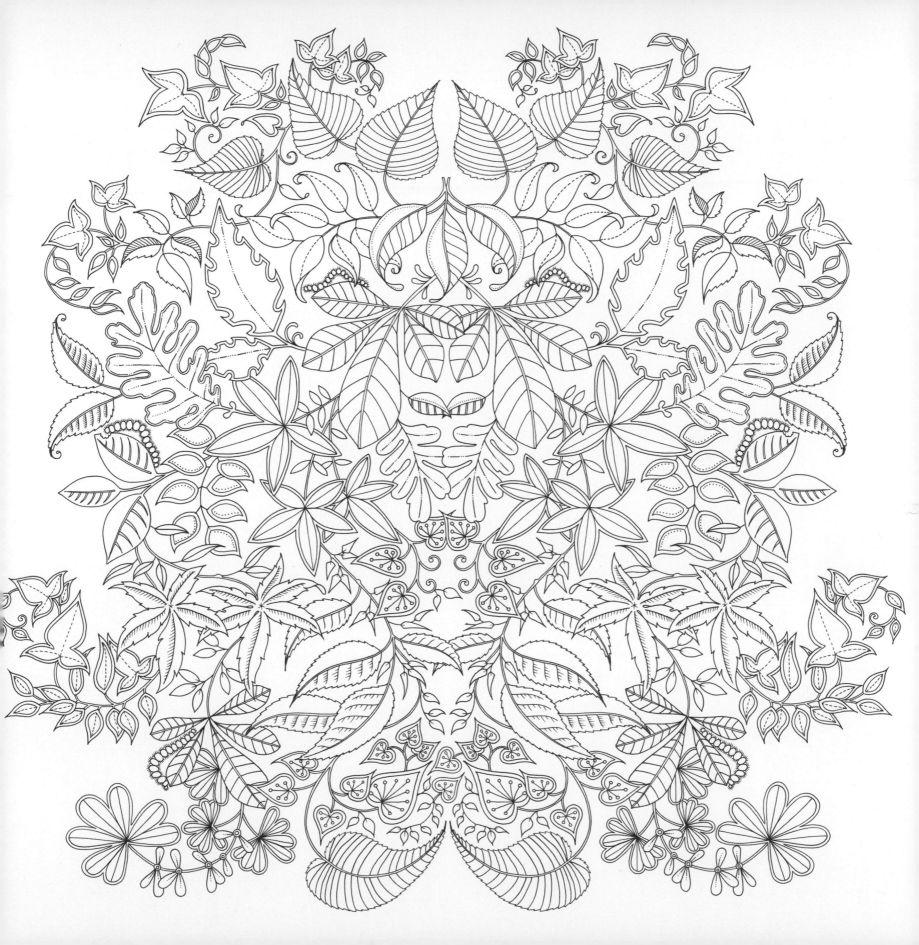

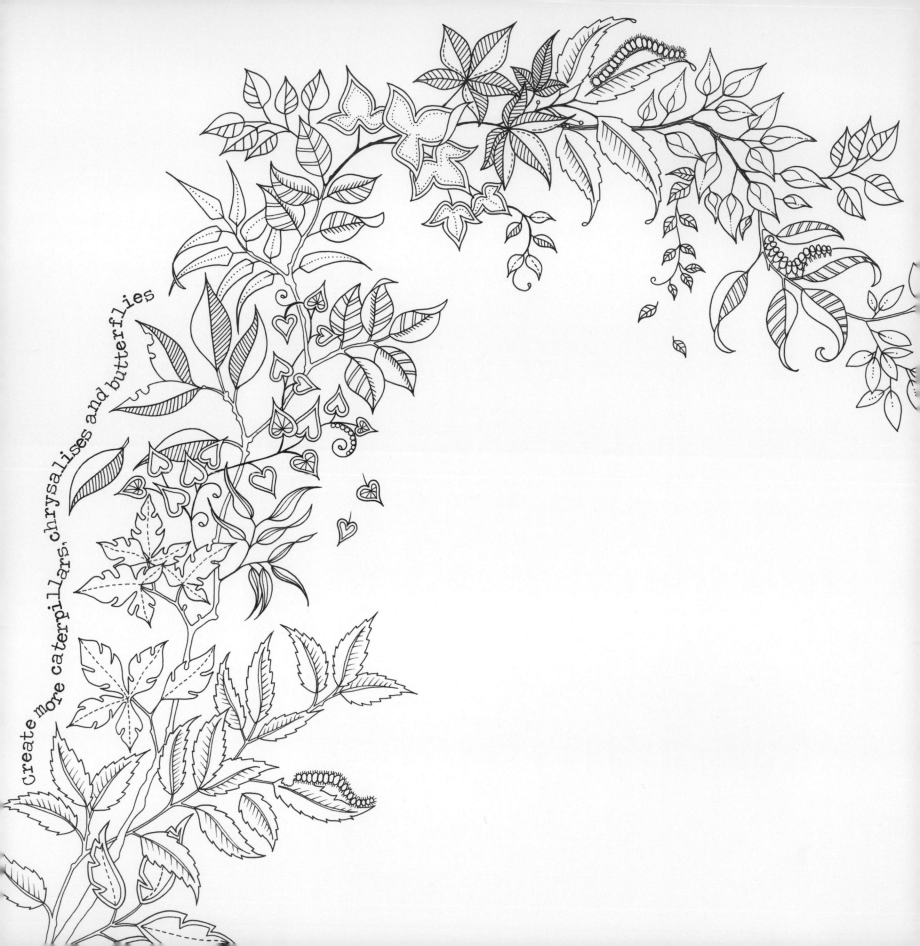

Create more caterpillars, chrysalises and butterflies

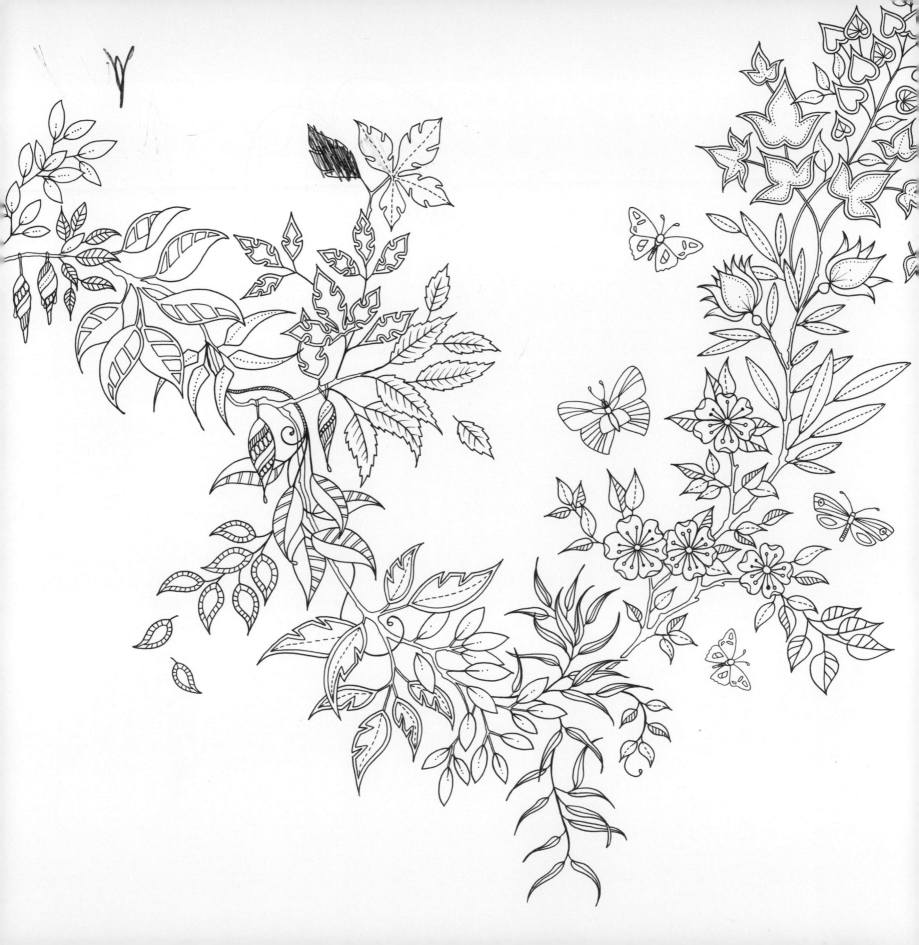

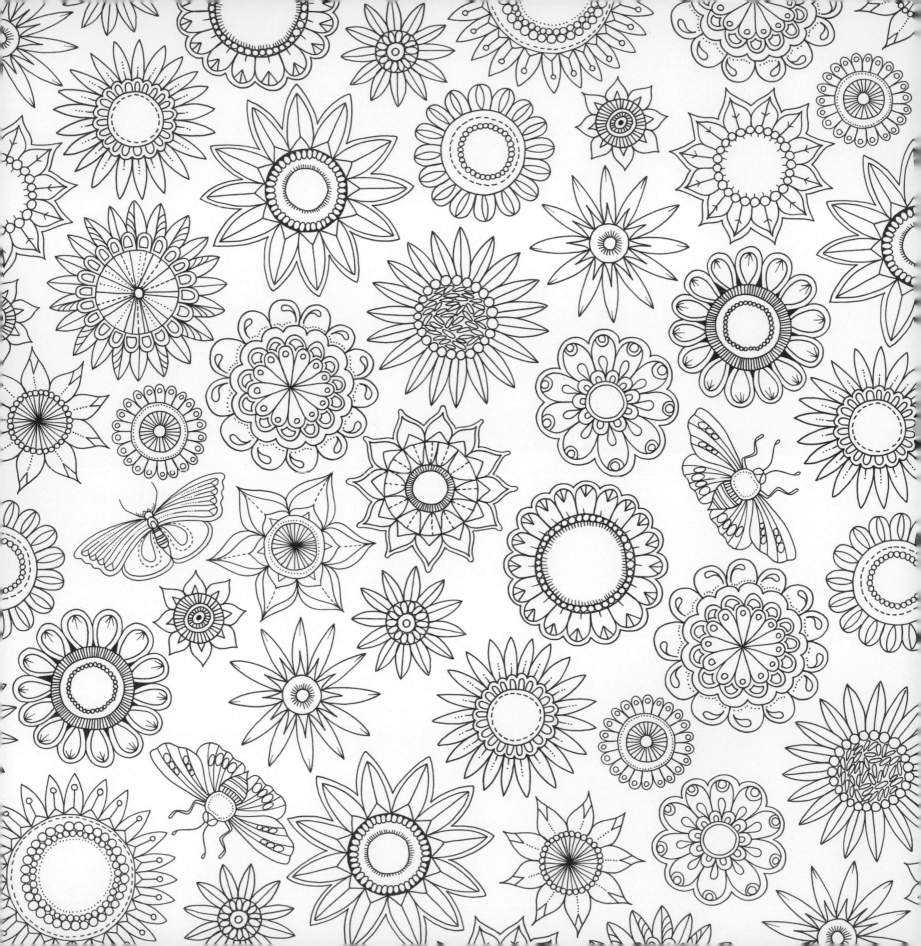

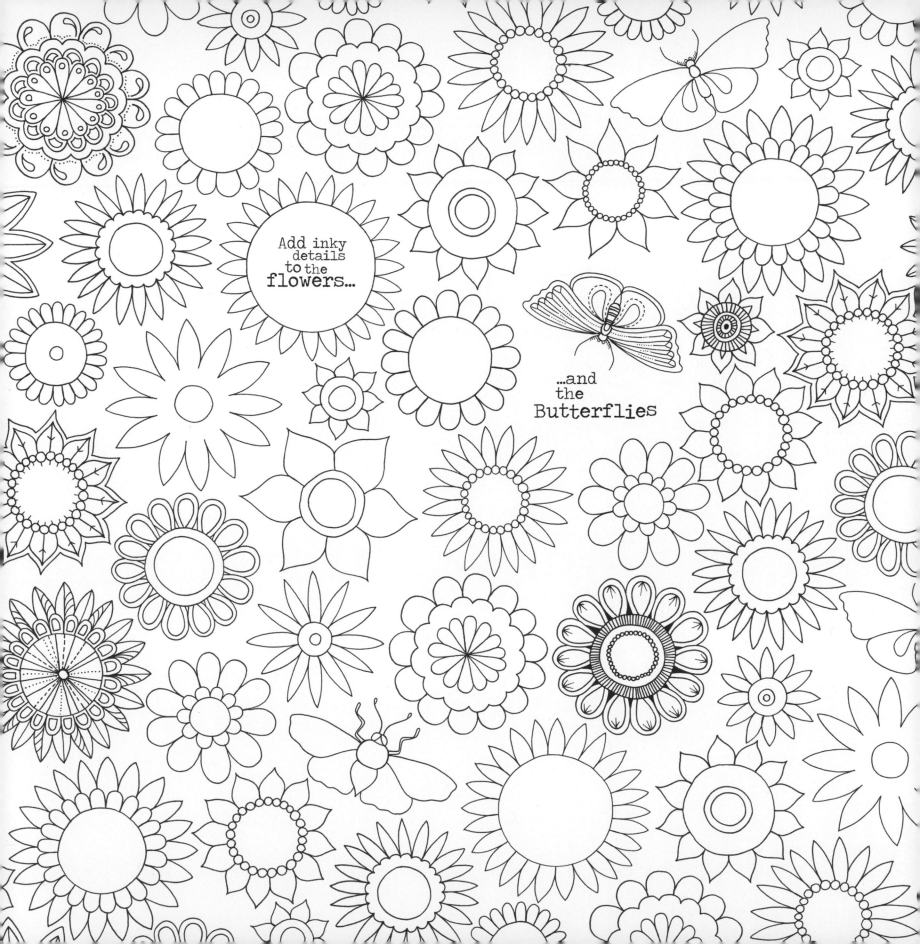

Add inky
details
to the
flowers...

...and
the
Butterflies

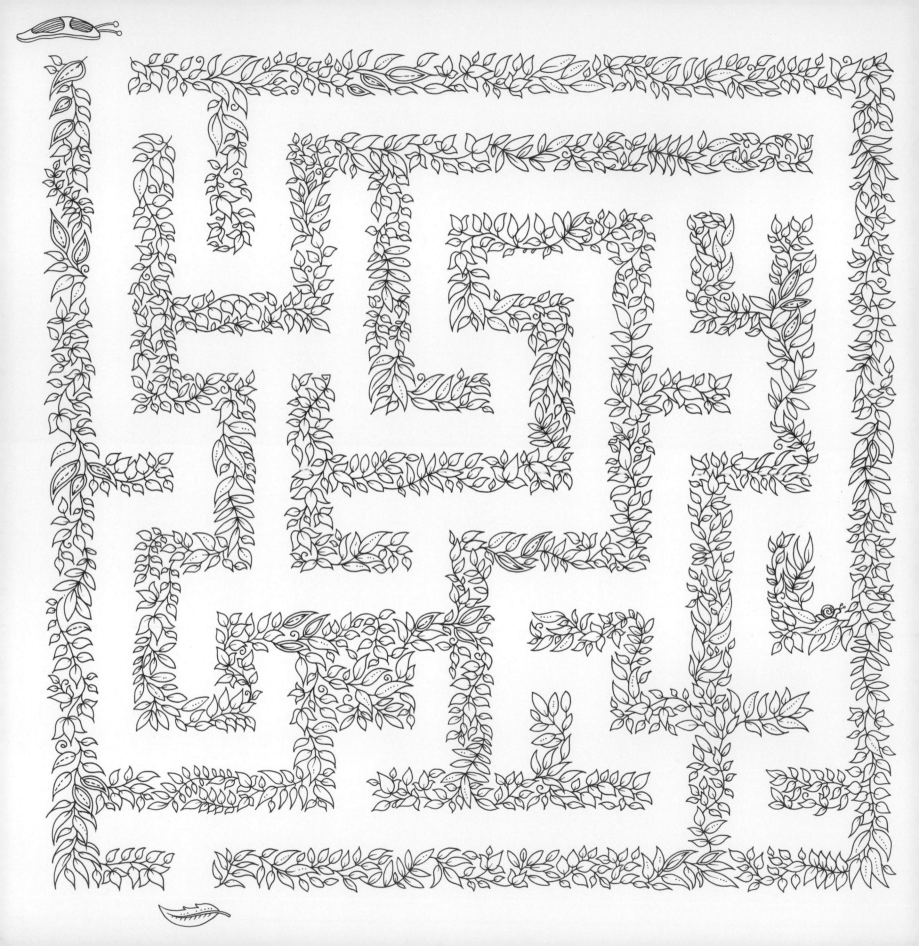

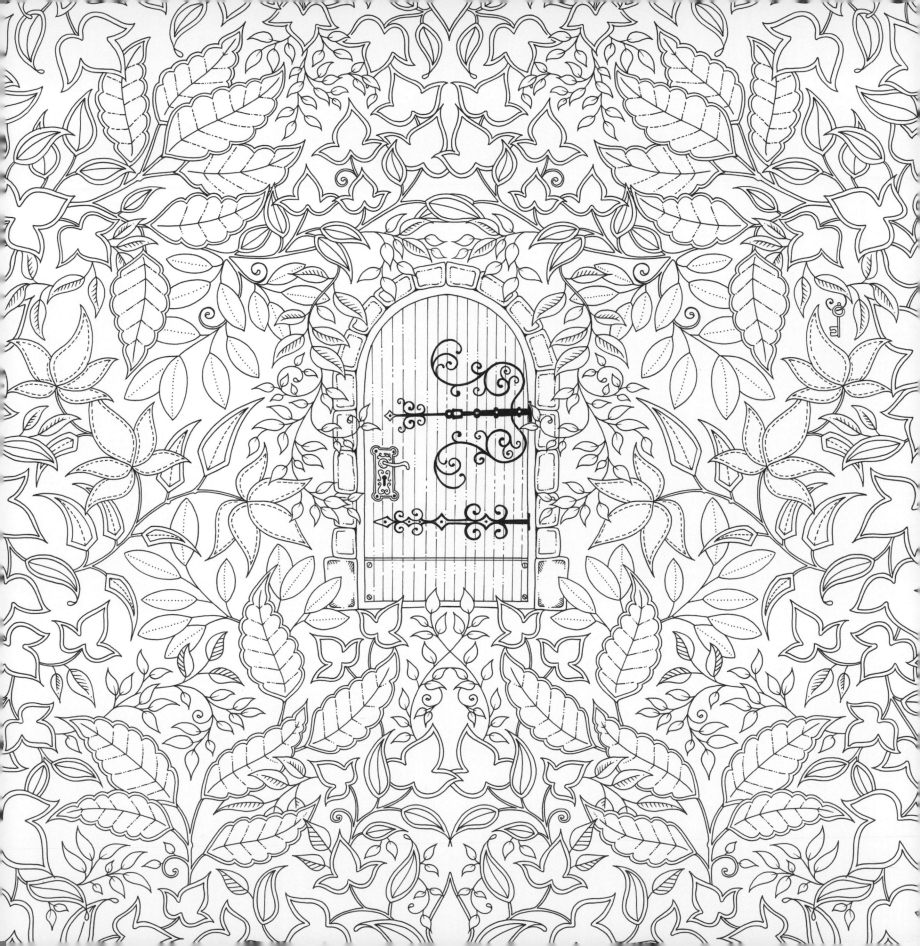

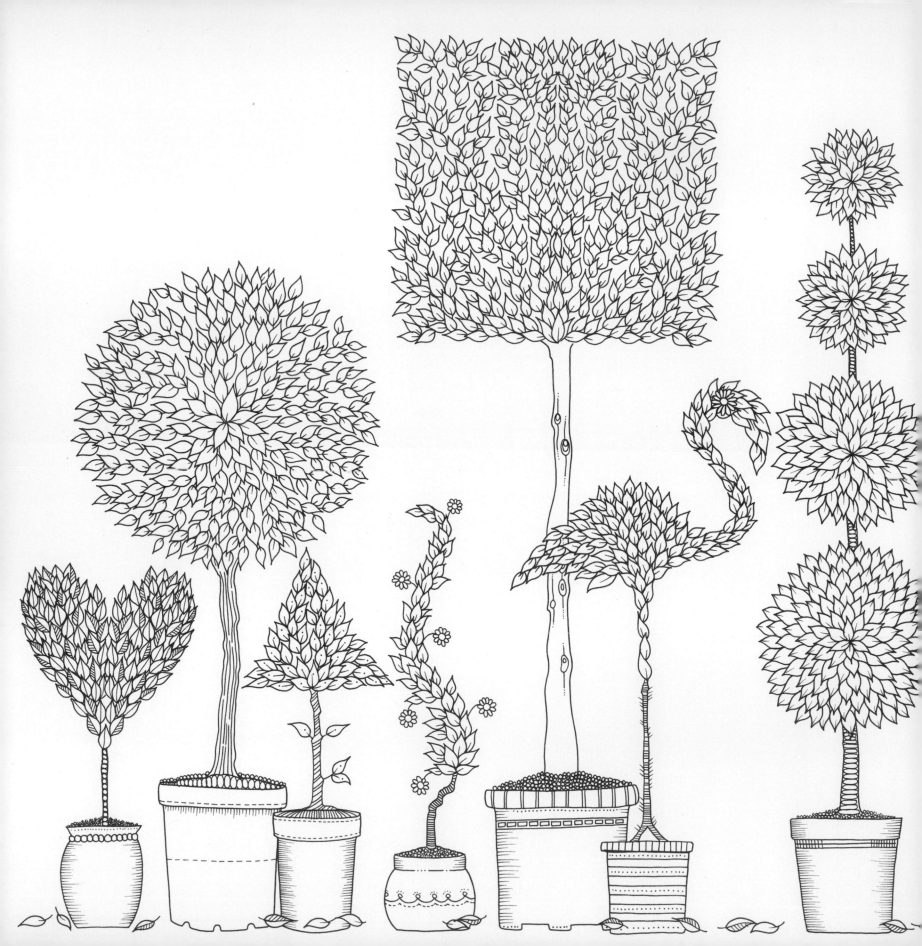

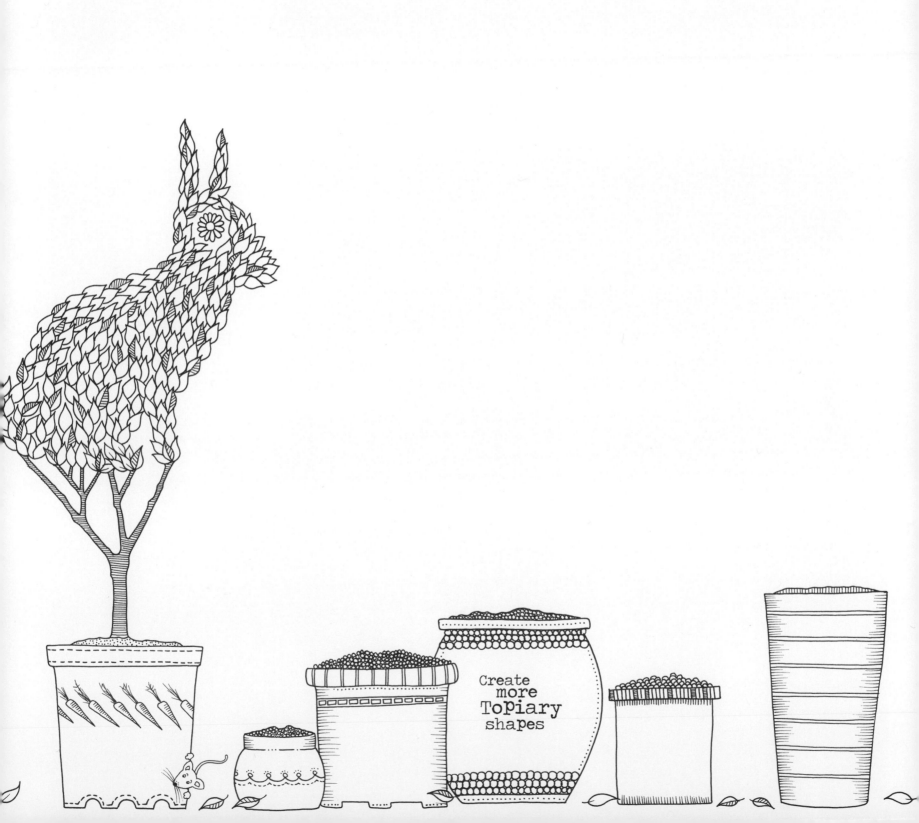

Create
more
Topiary
shapes

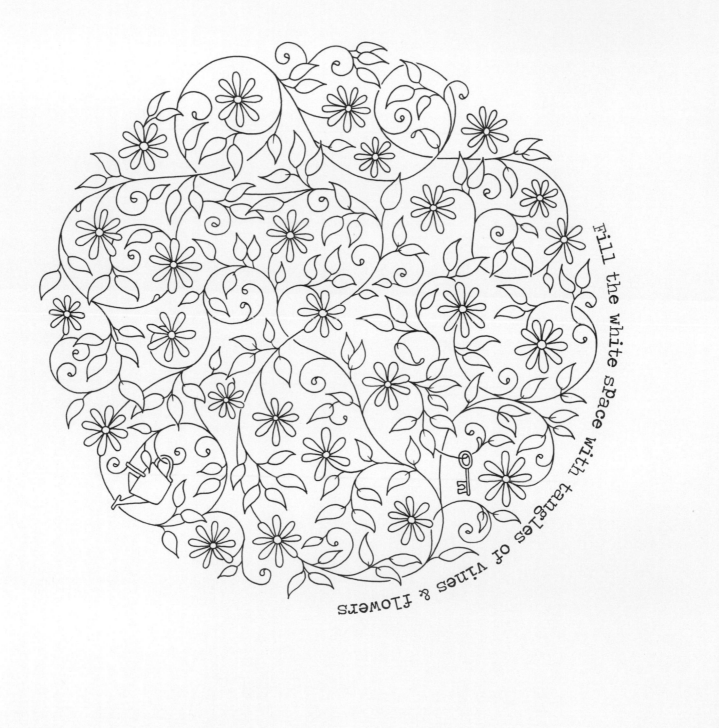

Fill the white space with tangles of vines & flowers

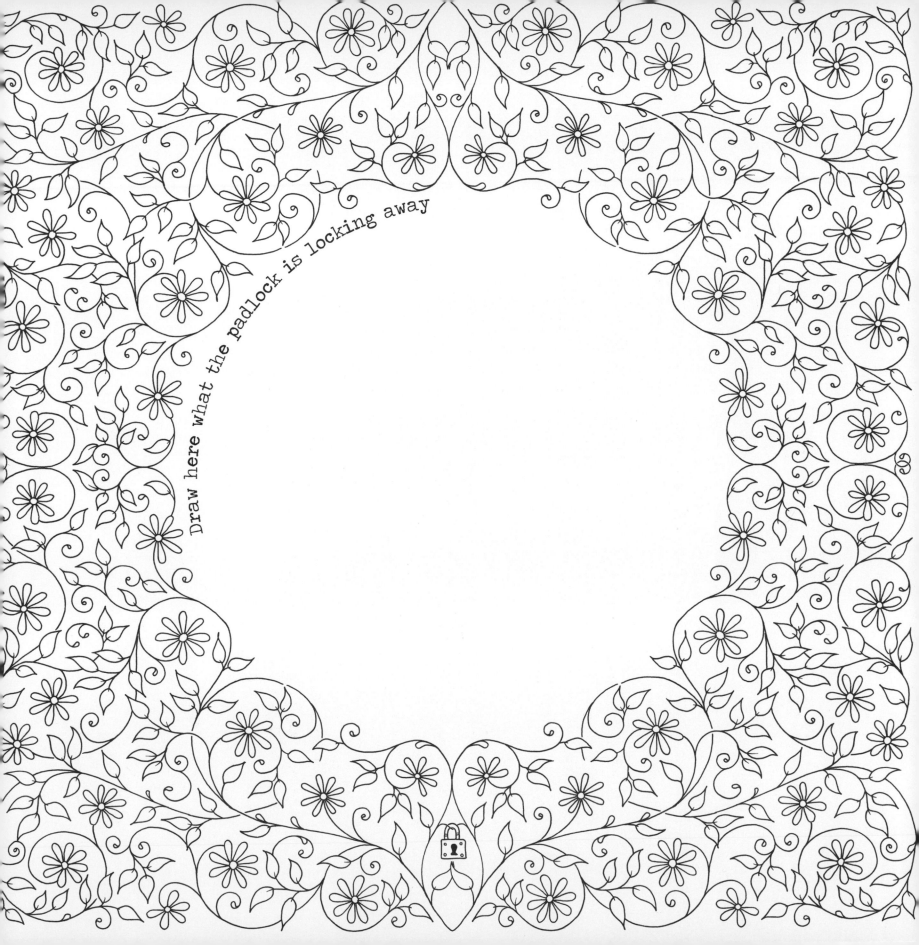

Draw here what the padlock is locking away

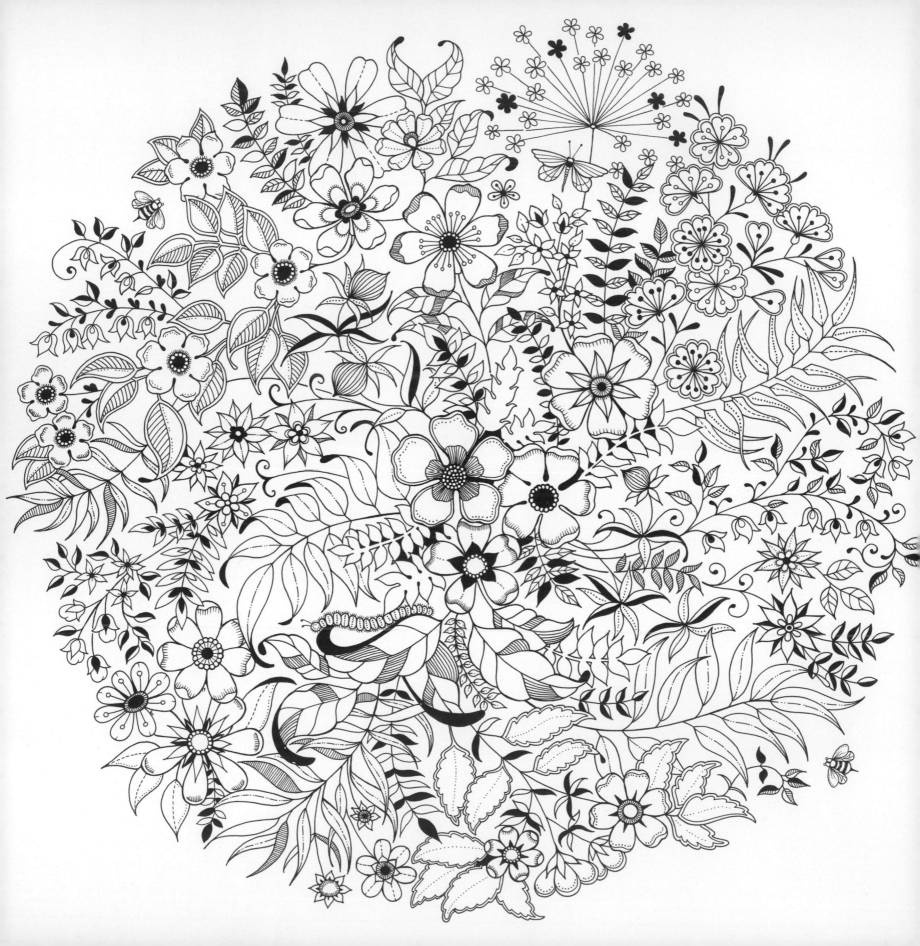

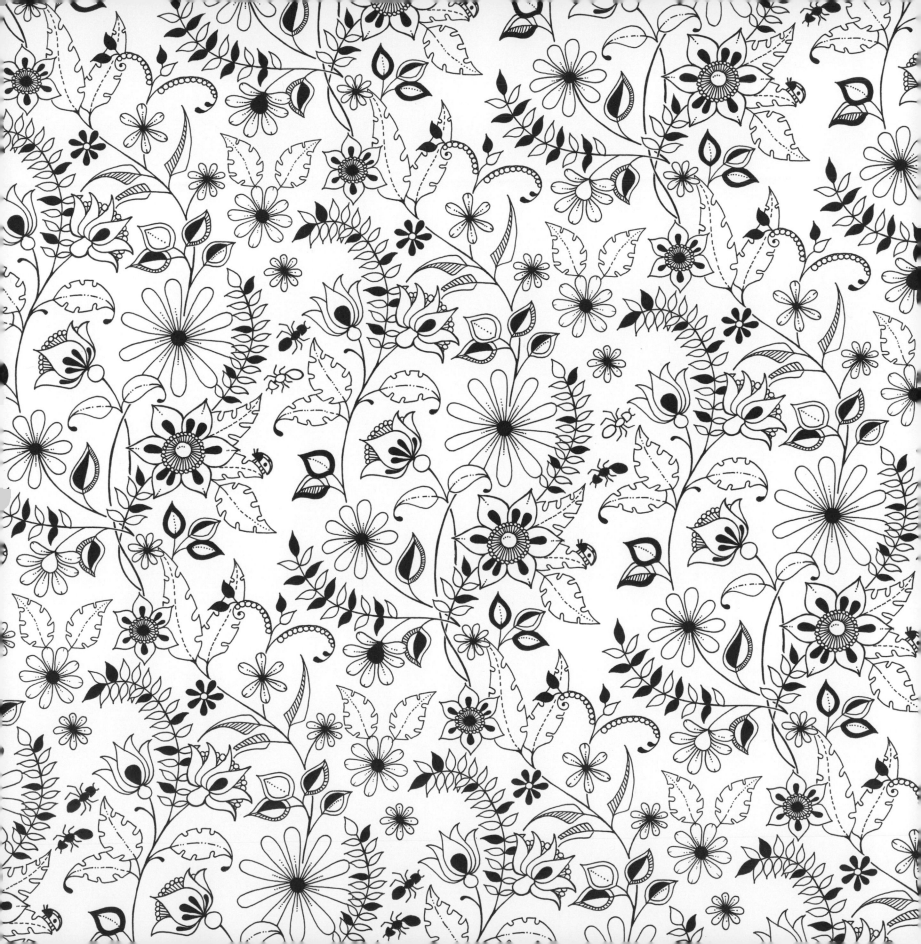

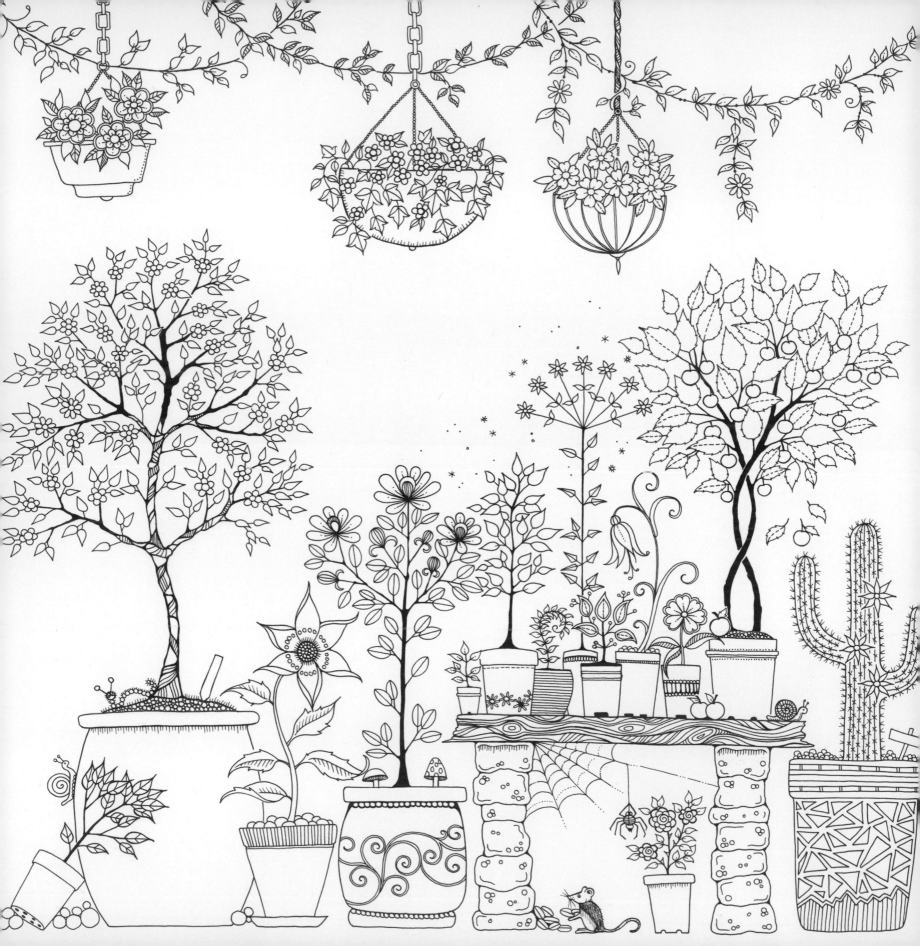

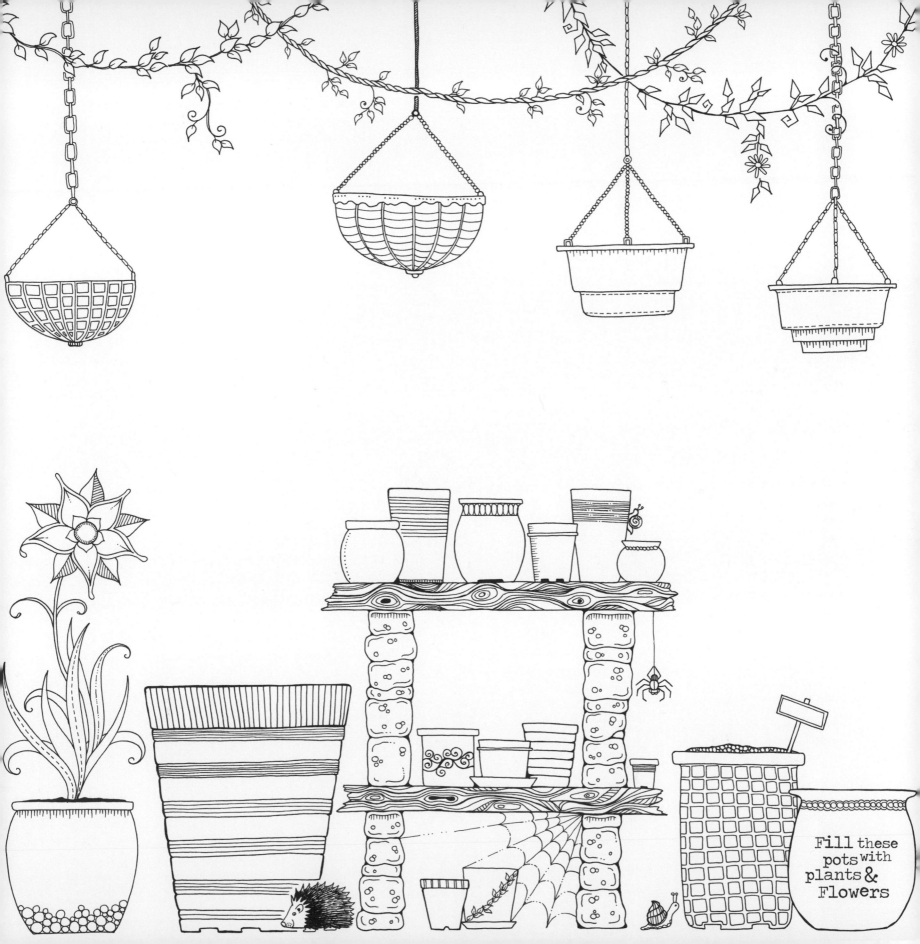

Fill these pots with plants & Flowers

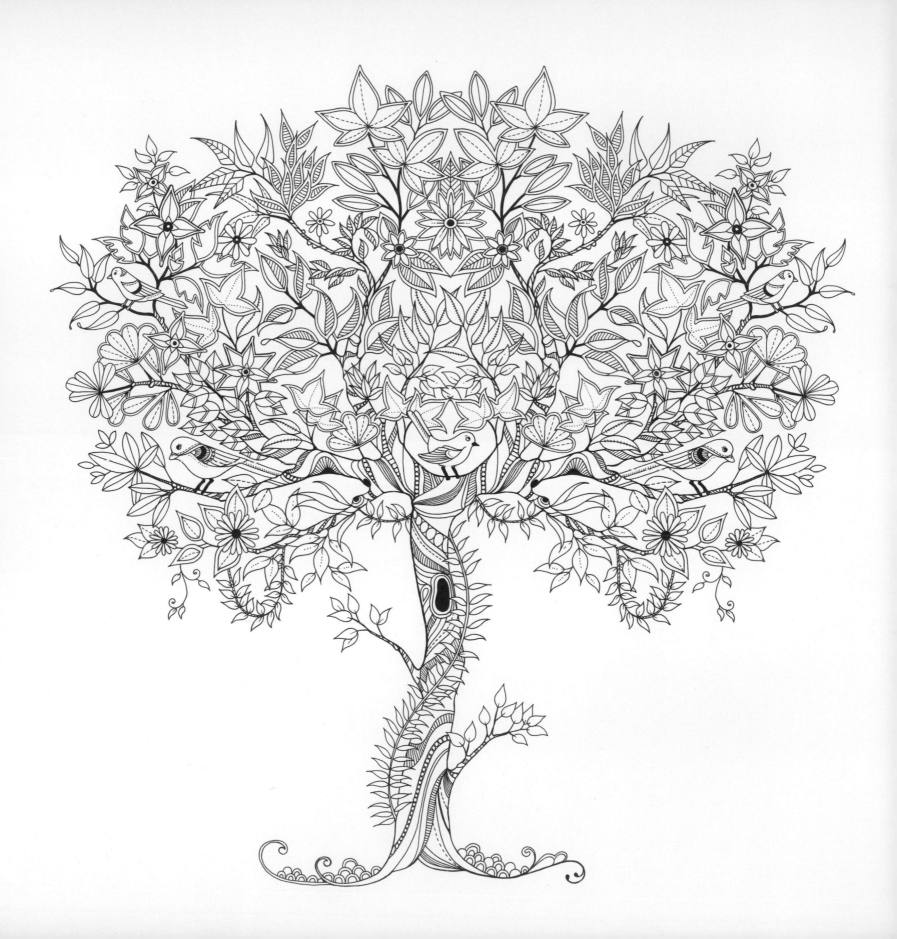

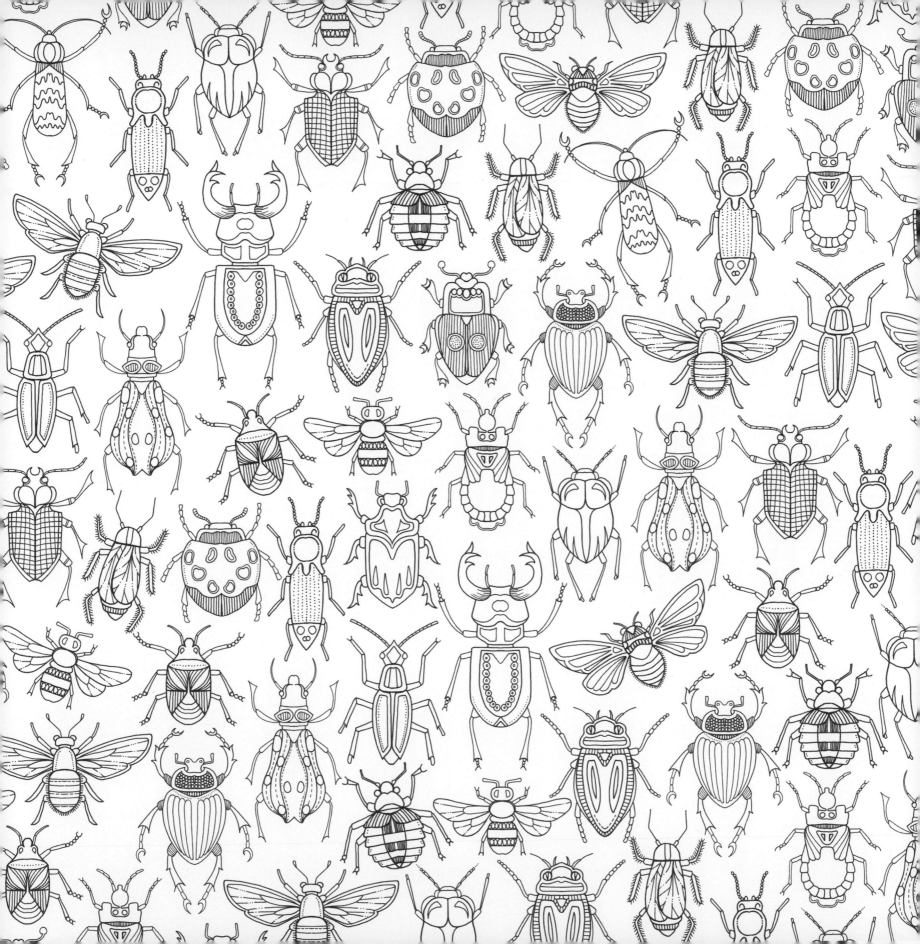

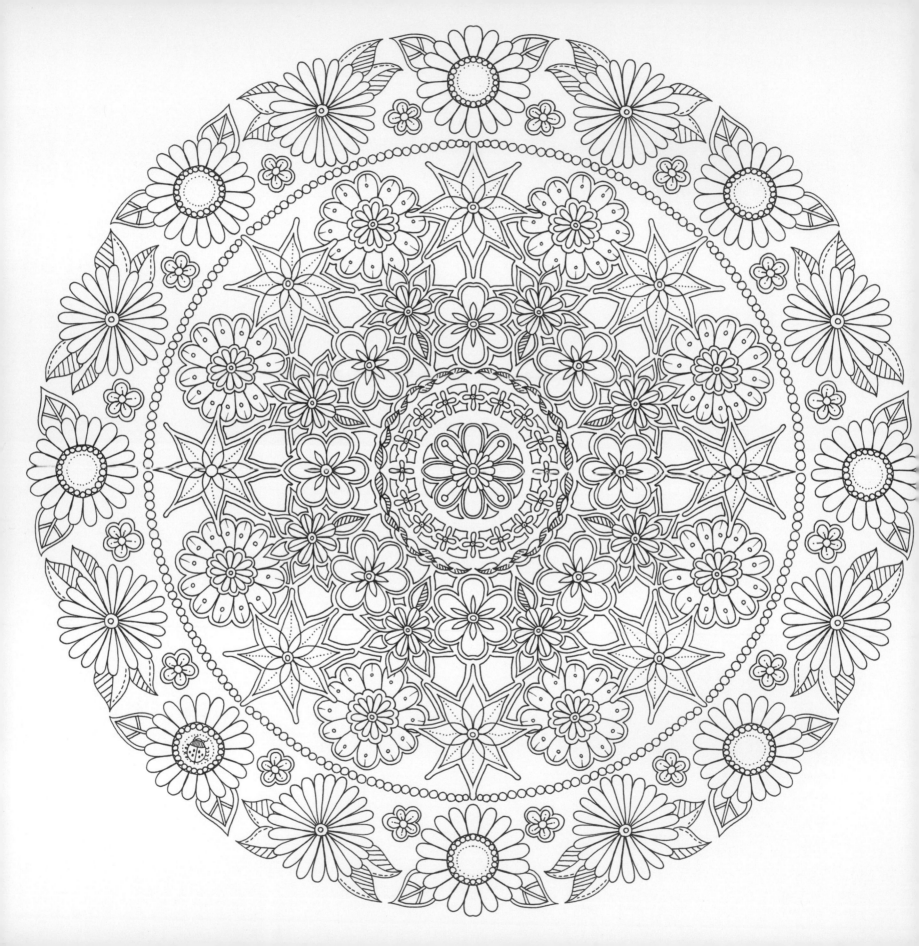

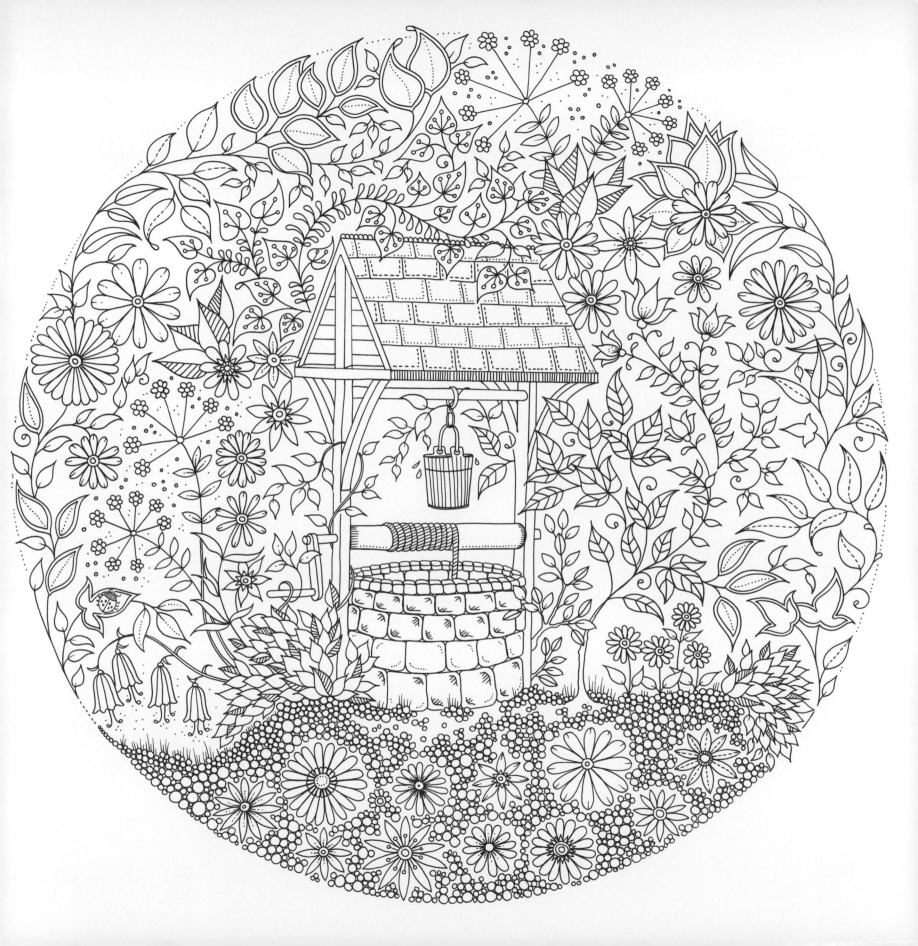

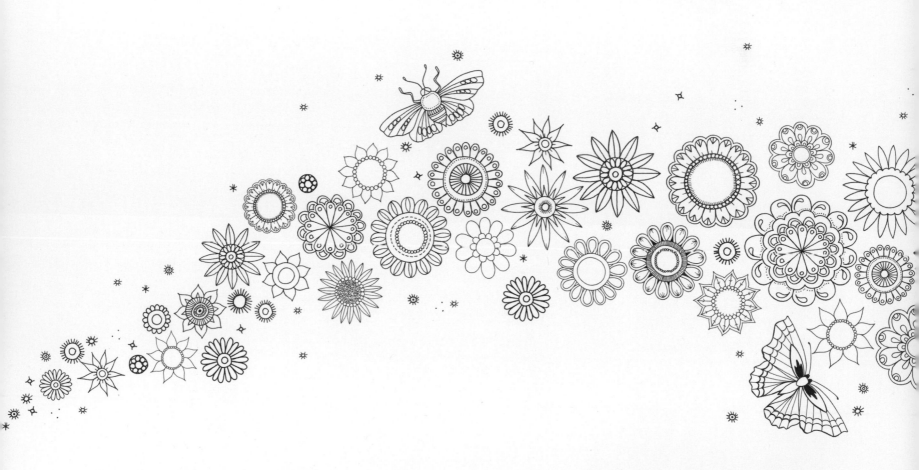

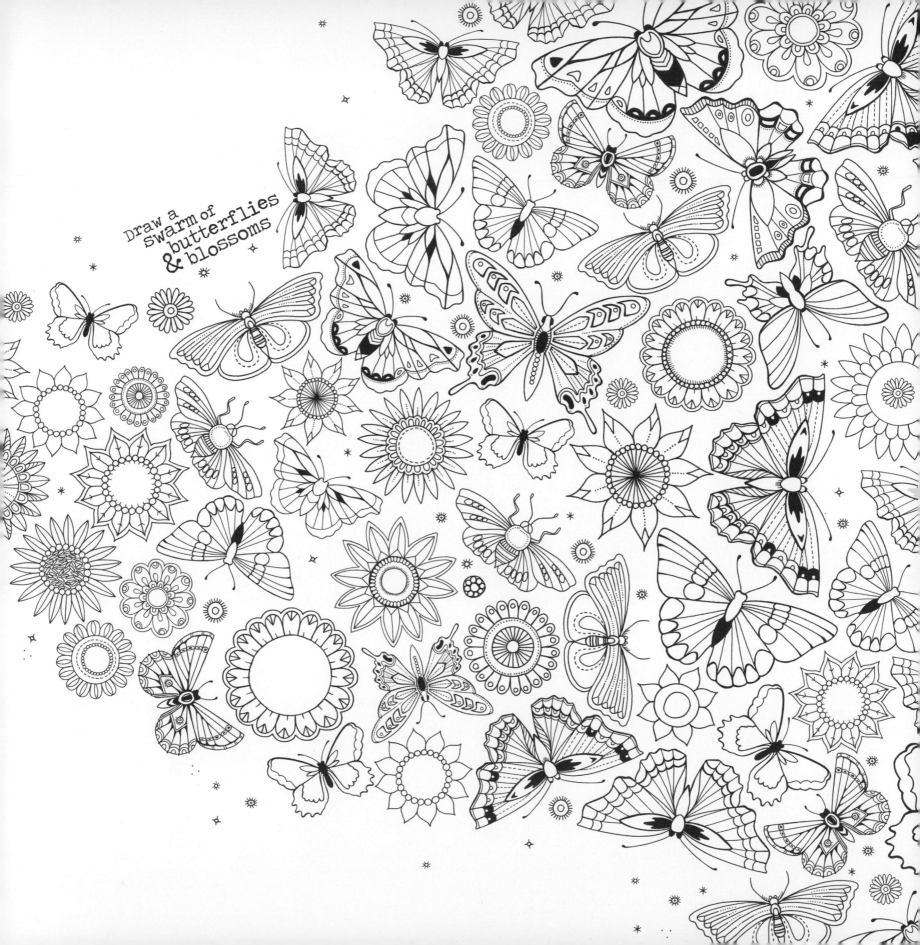

Draw a swarm of butterflies & blossoms

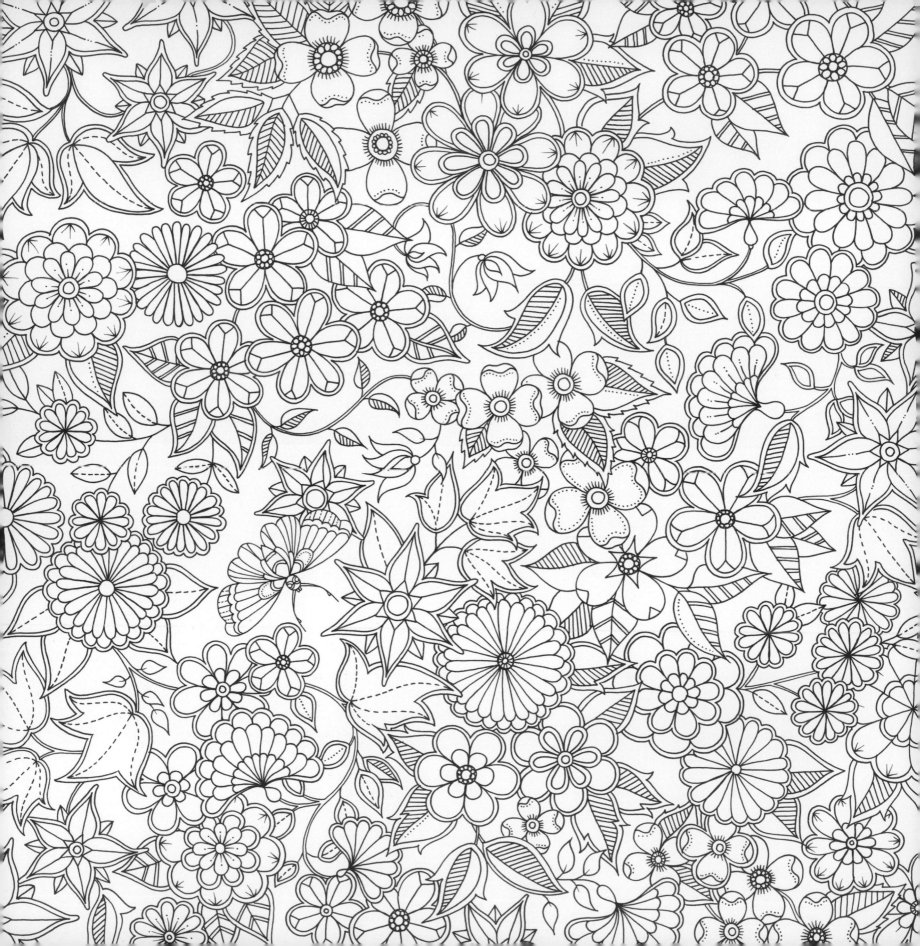

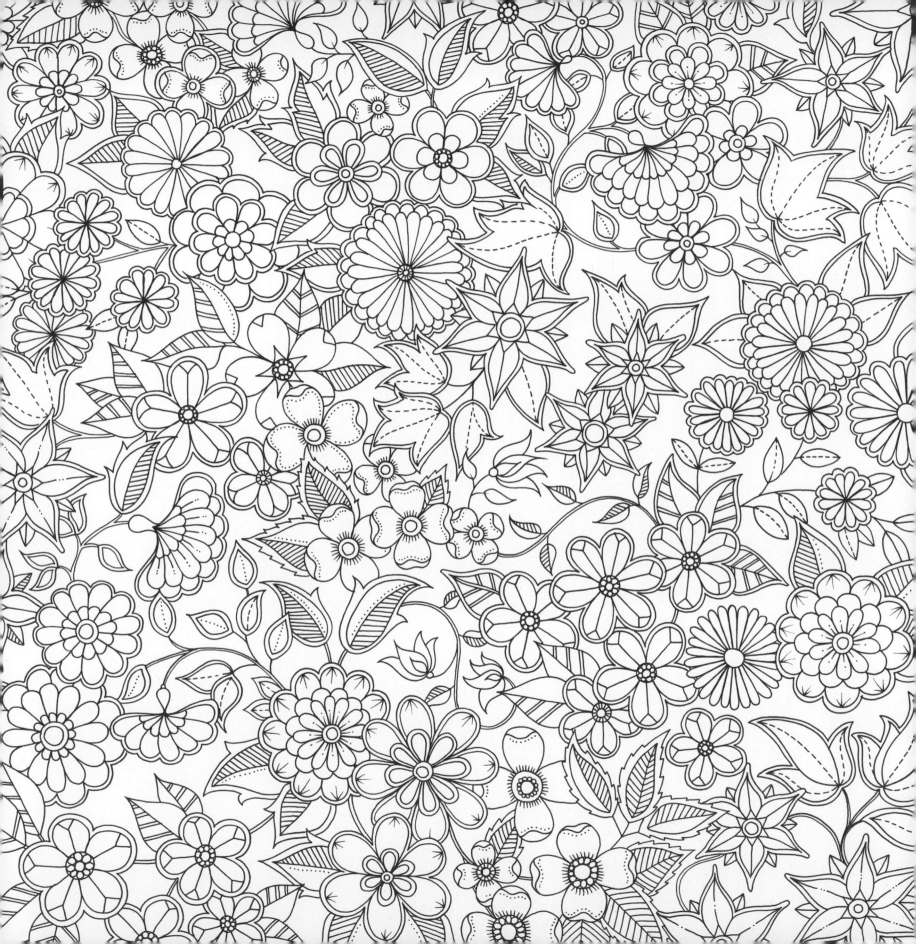

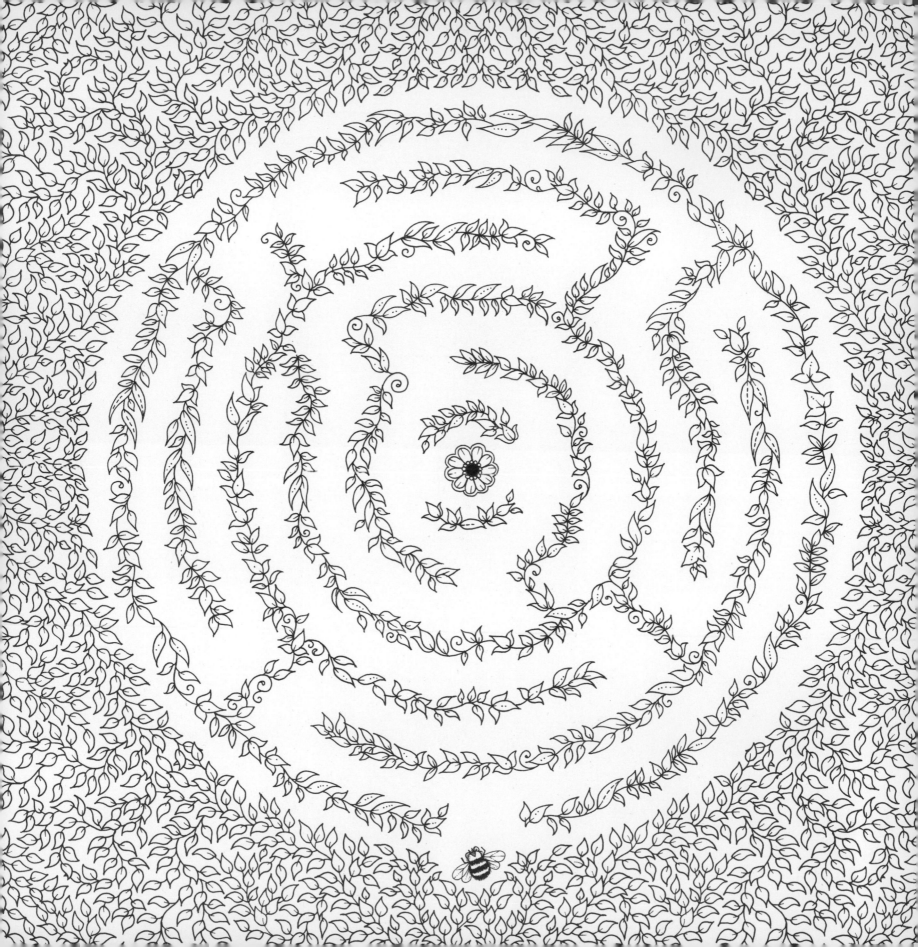

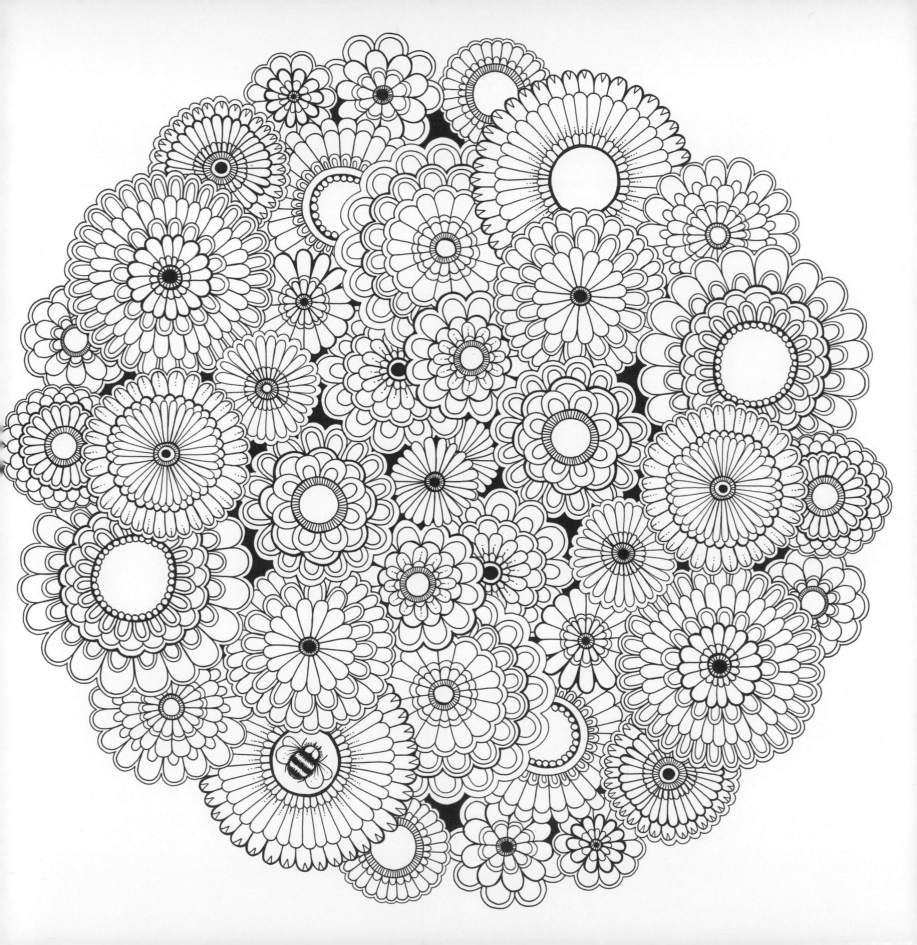

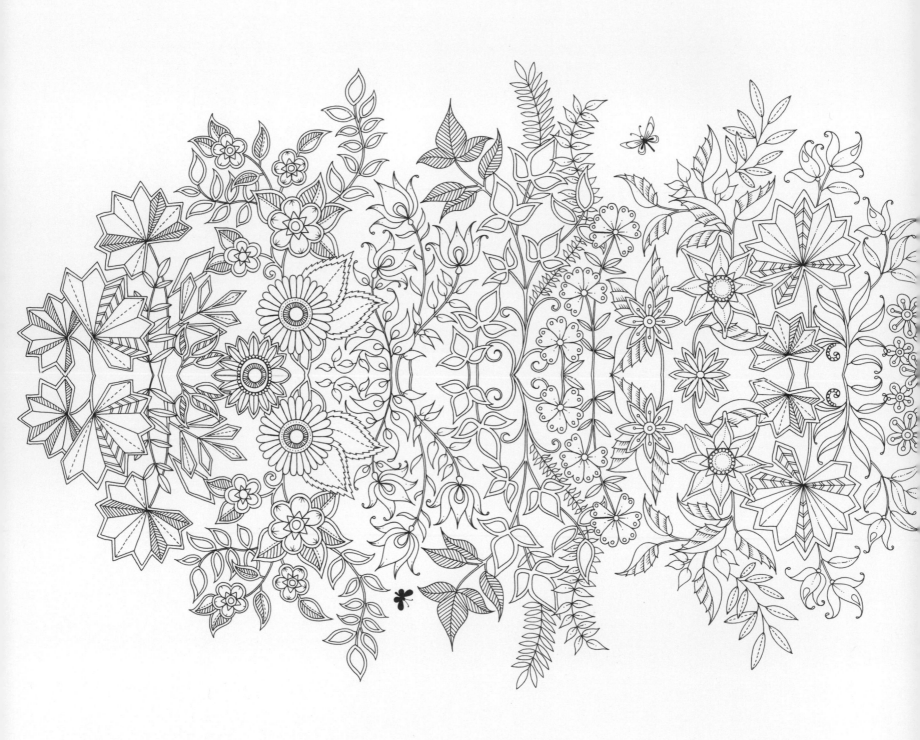

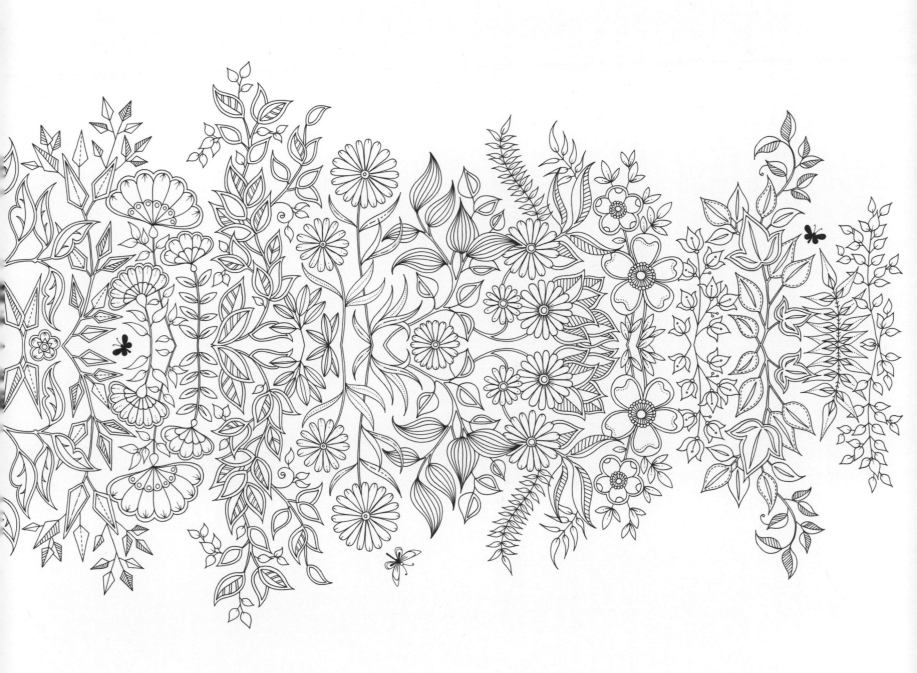

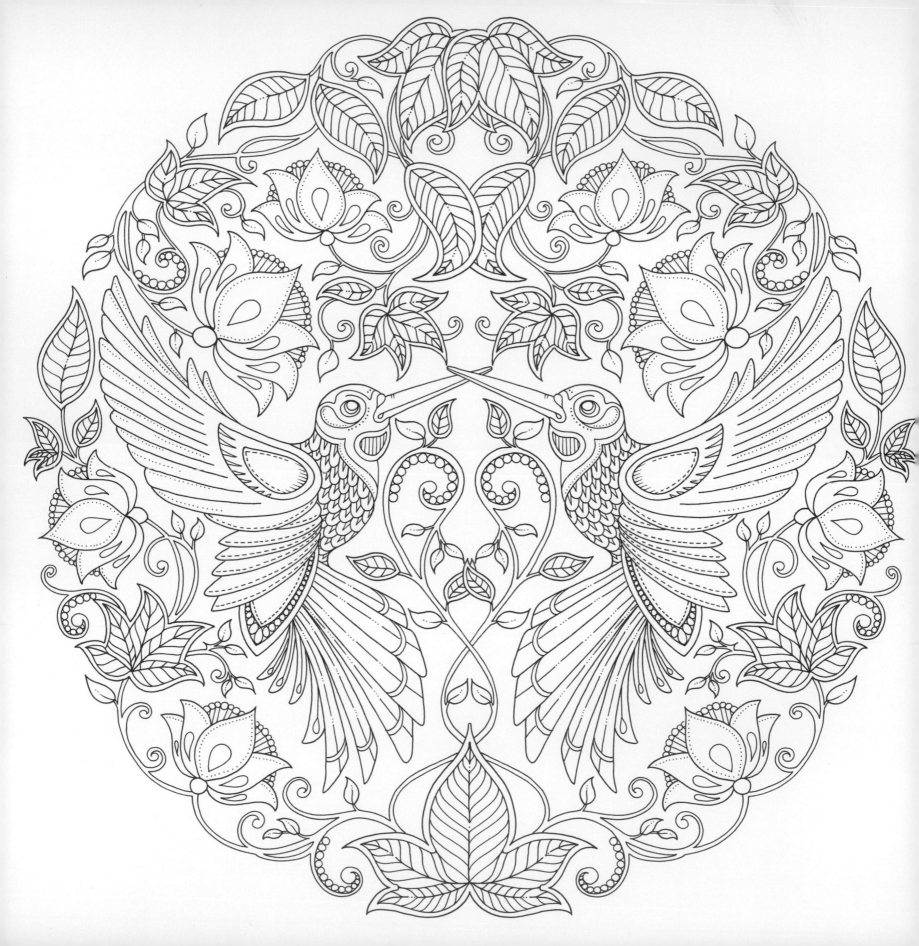

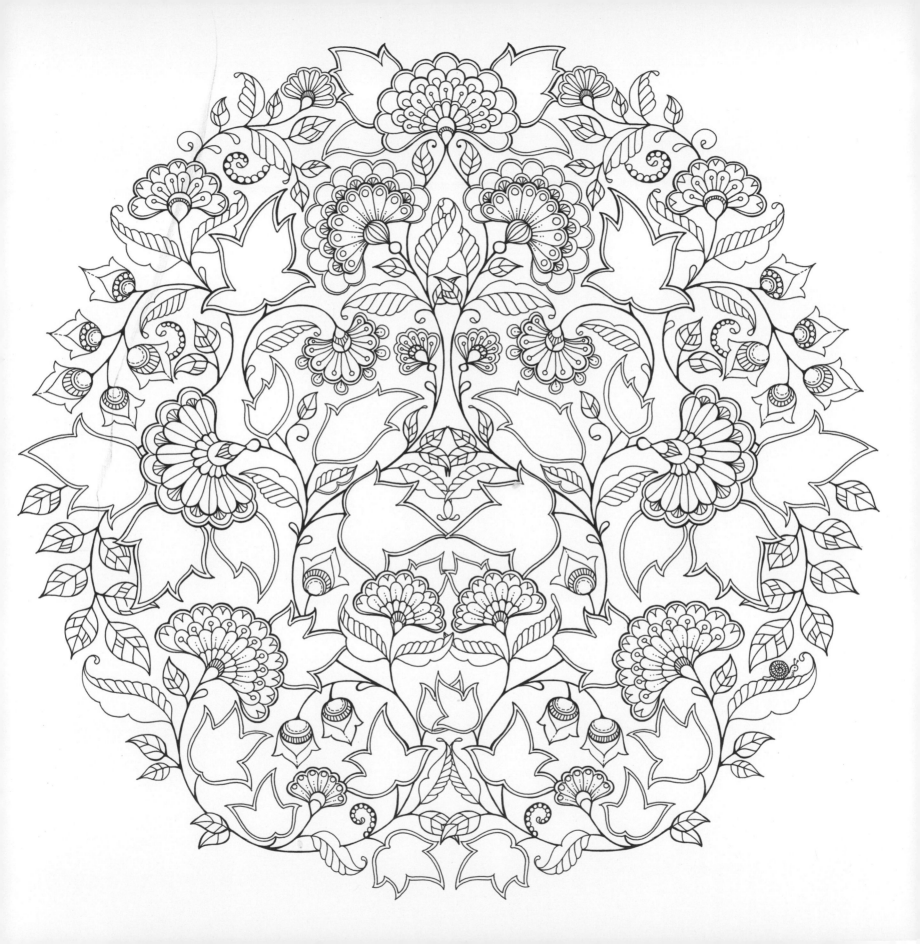

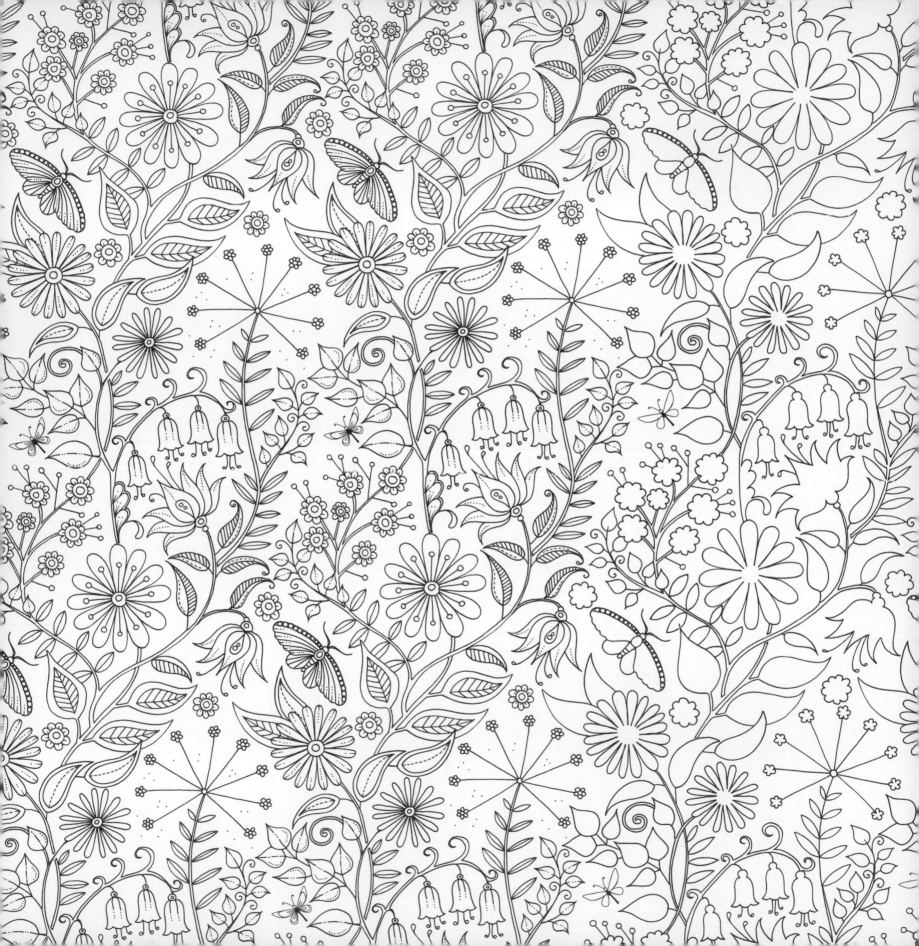

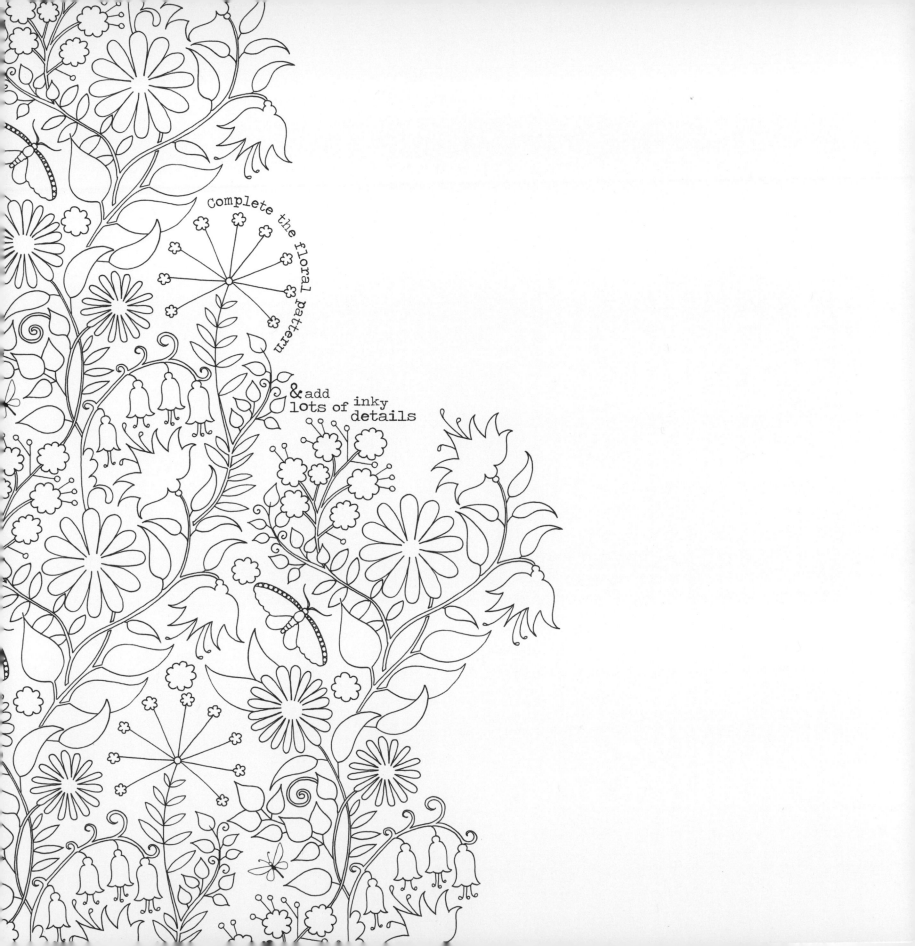

complete the floral pattern

& add lots of inky details

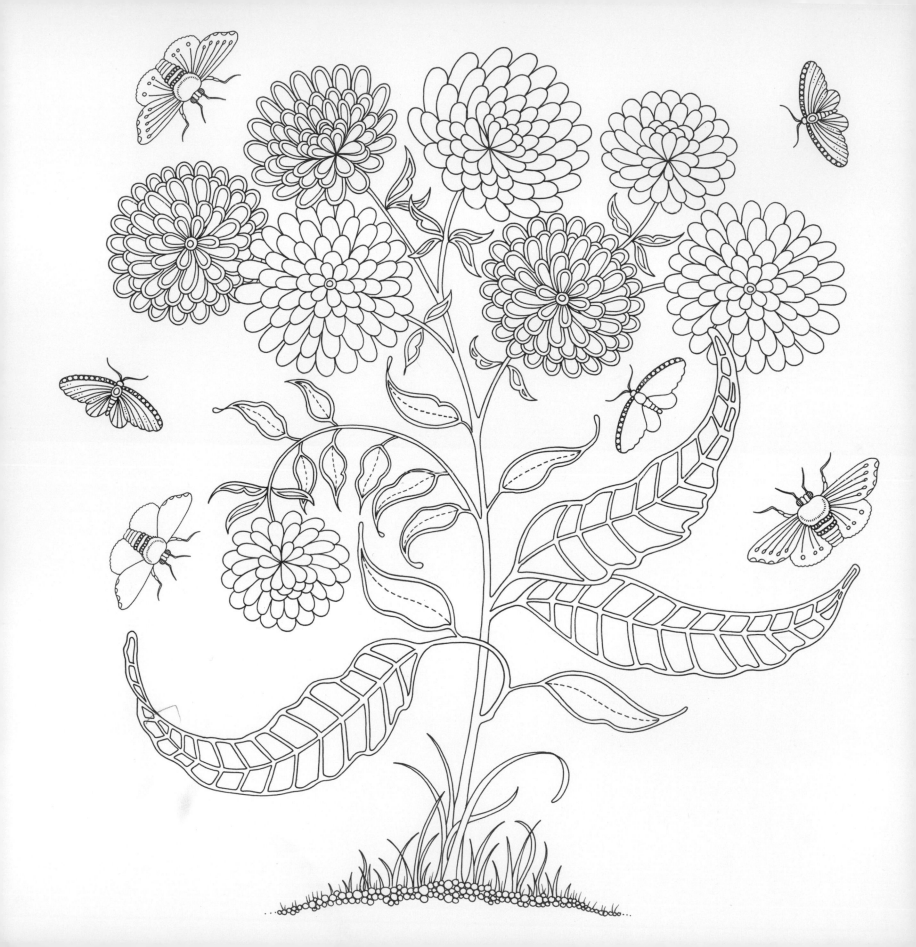

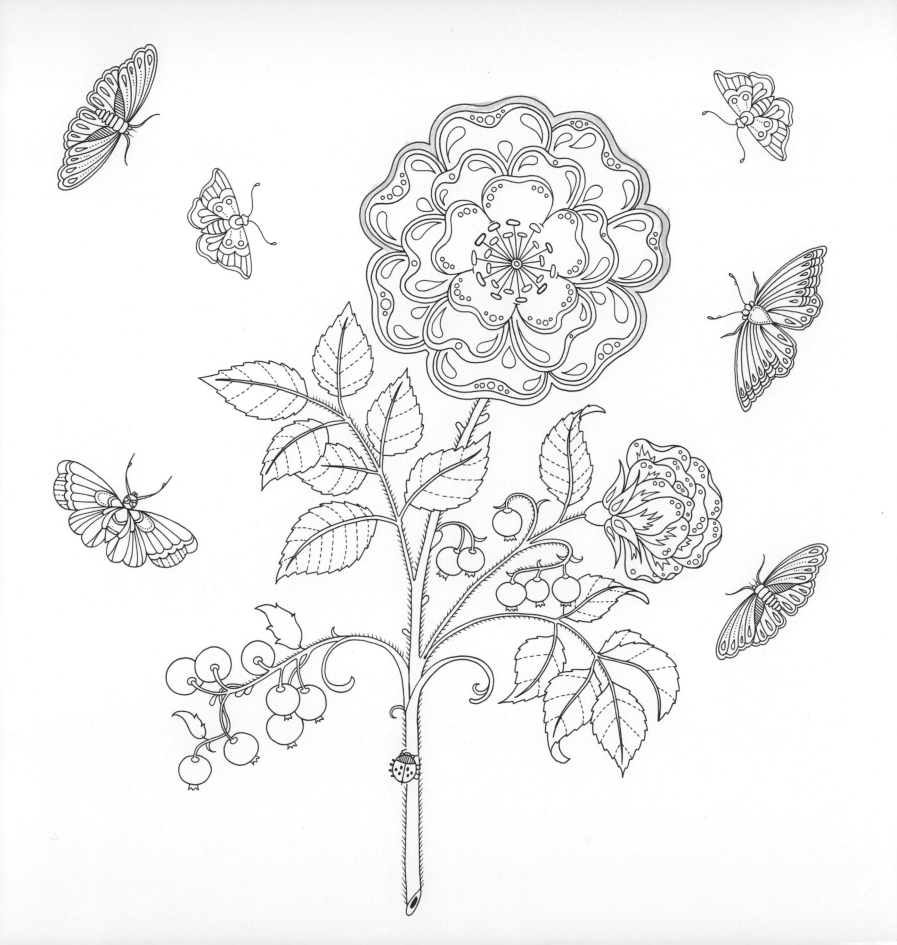

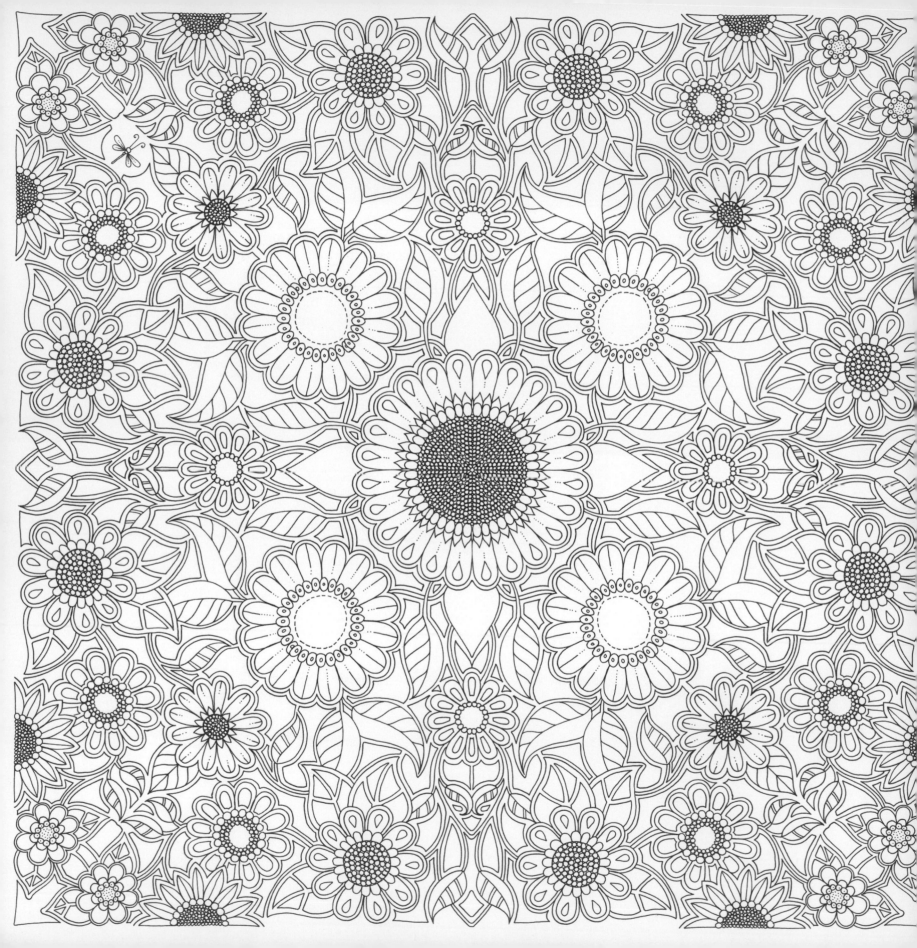

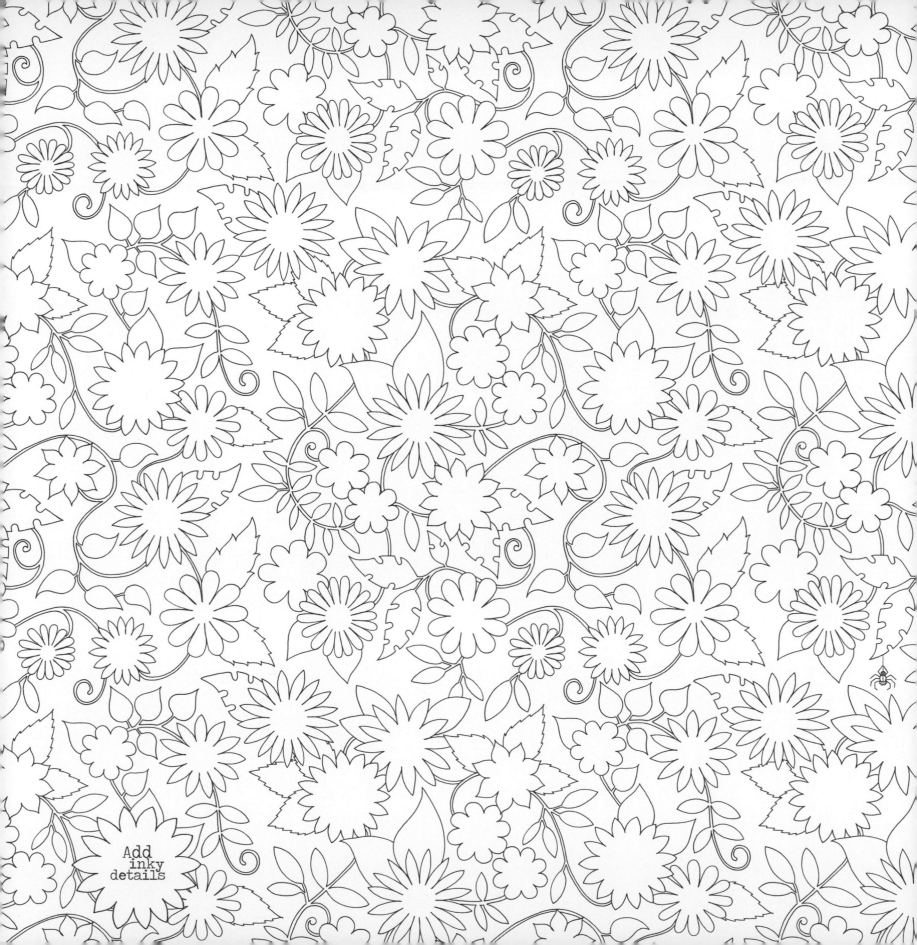

Add
inky
details

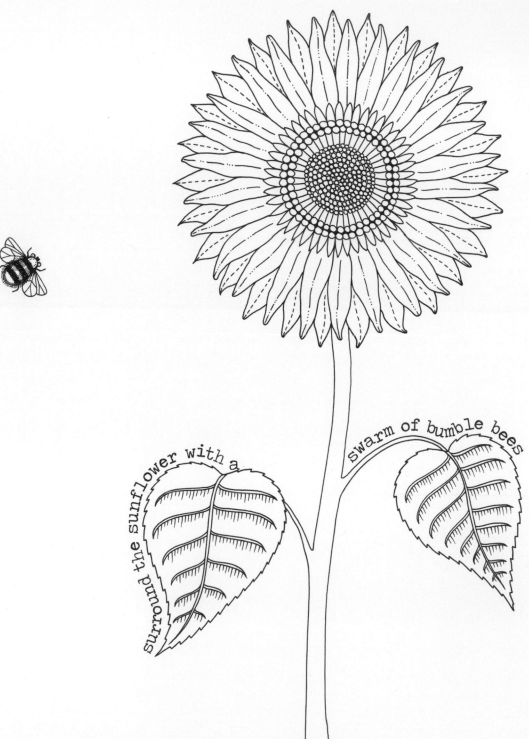

surround the sunflower with a swarm of bumble bees

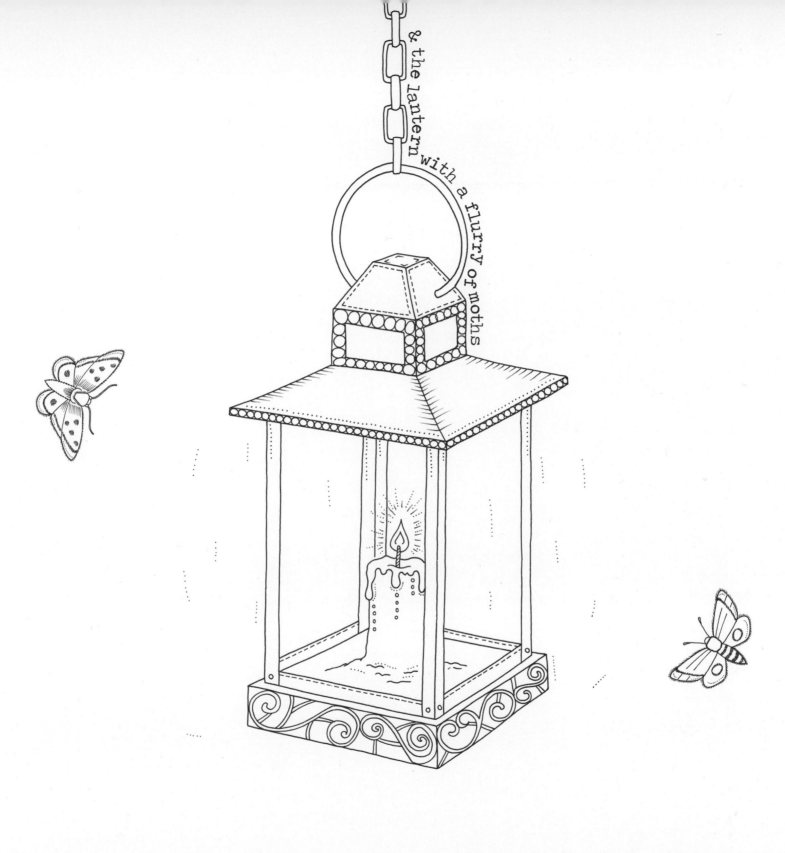

& the lantern with a flurry of moths

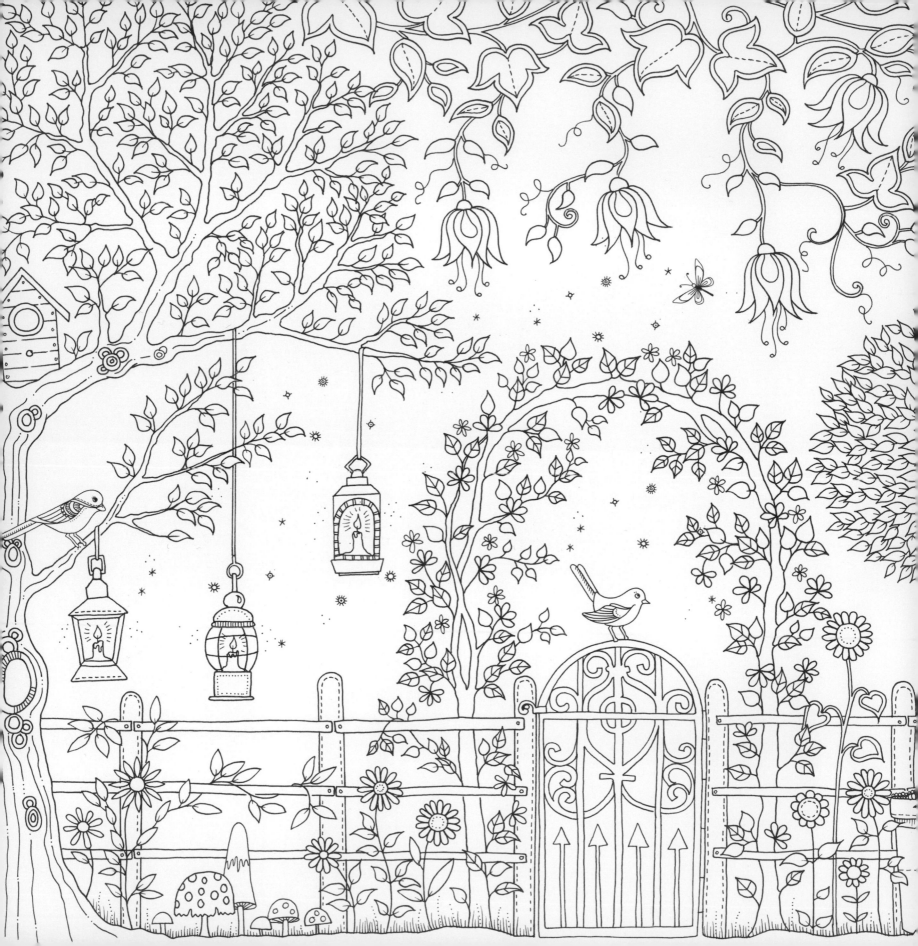

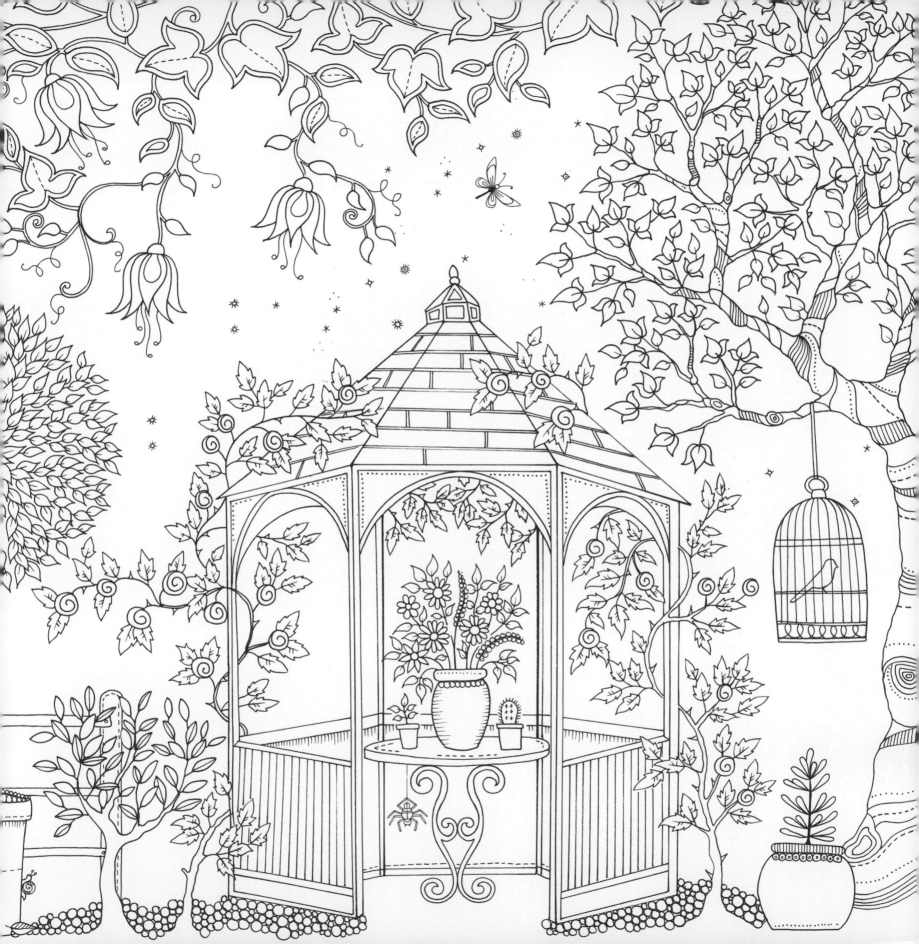

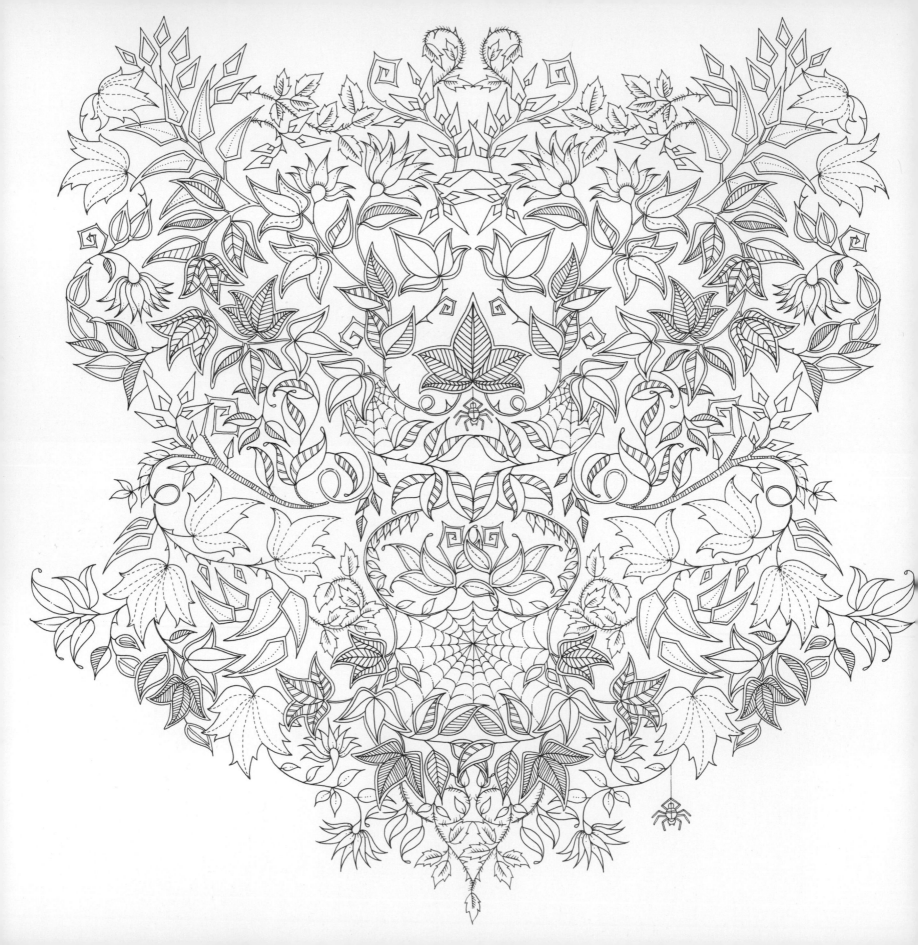

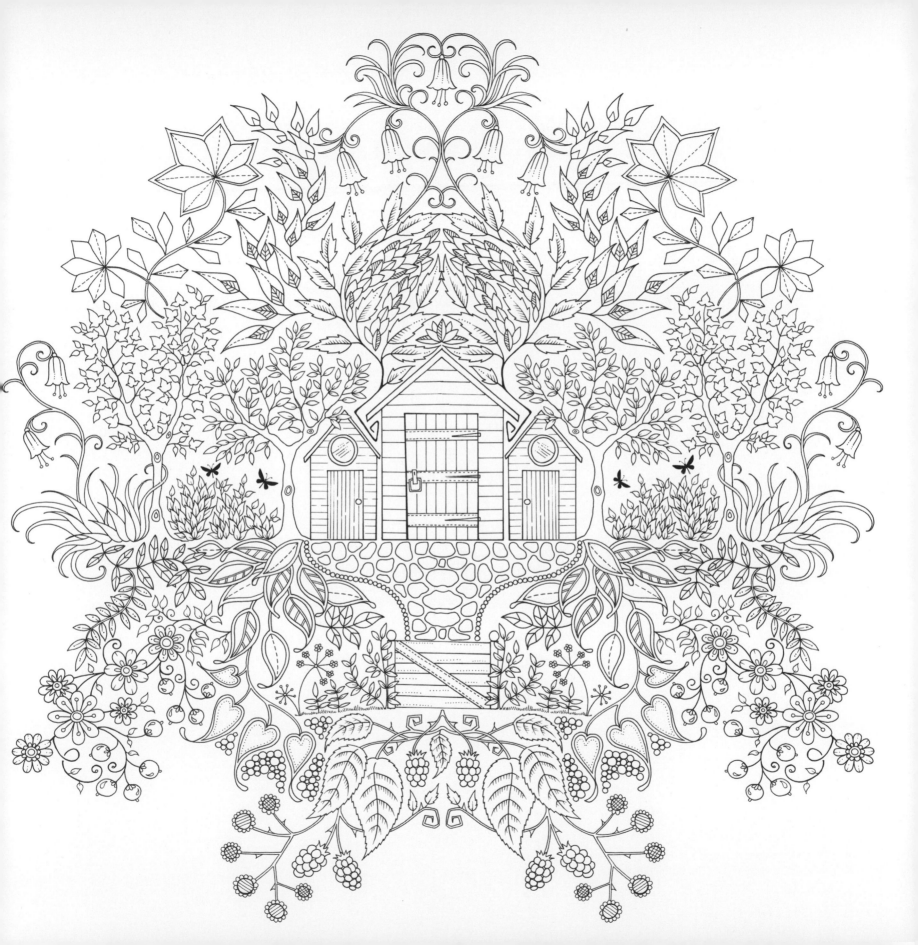

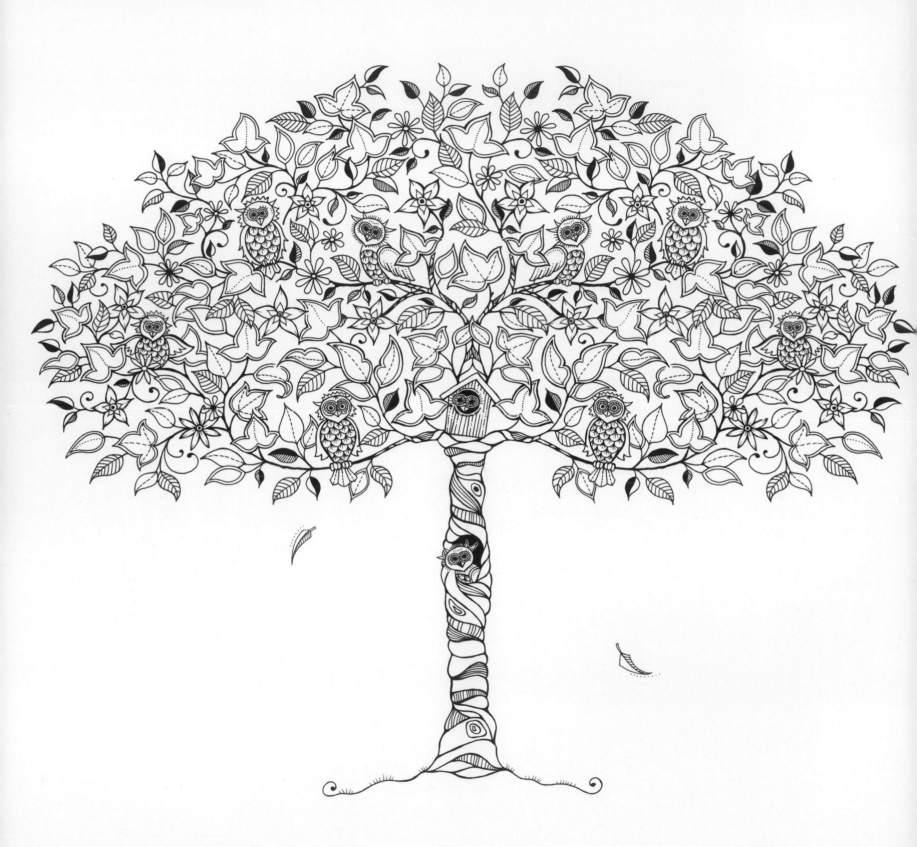

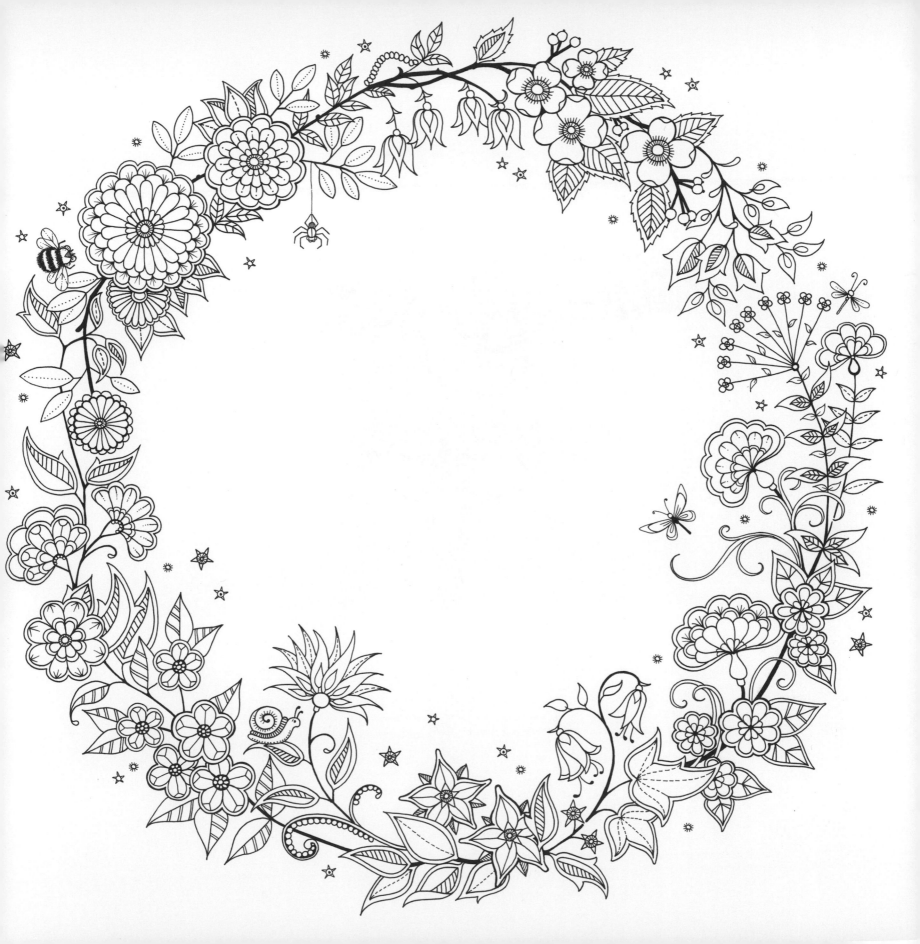

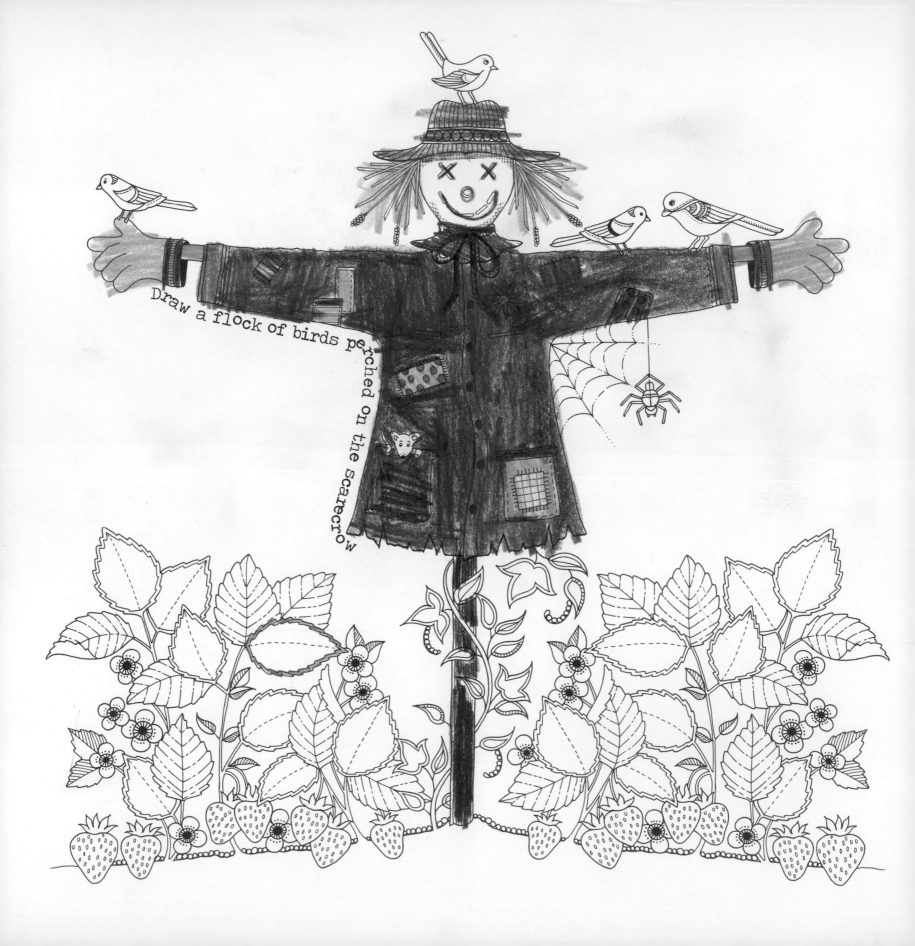

Draw a flock of birds perched on the scarecrow

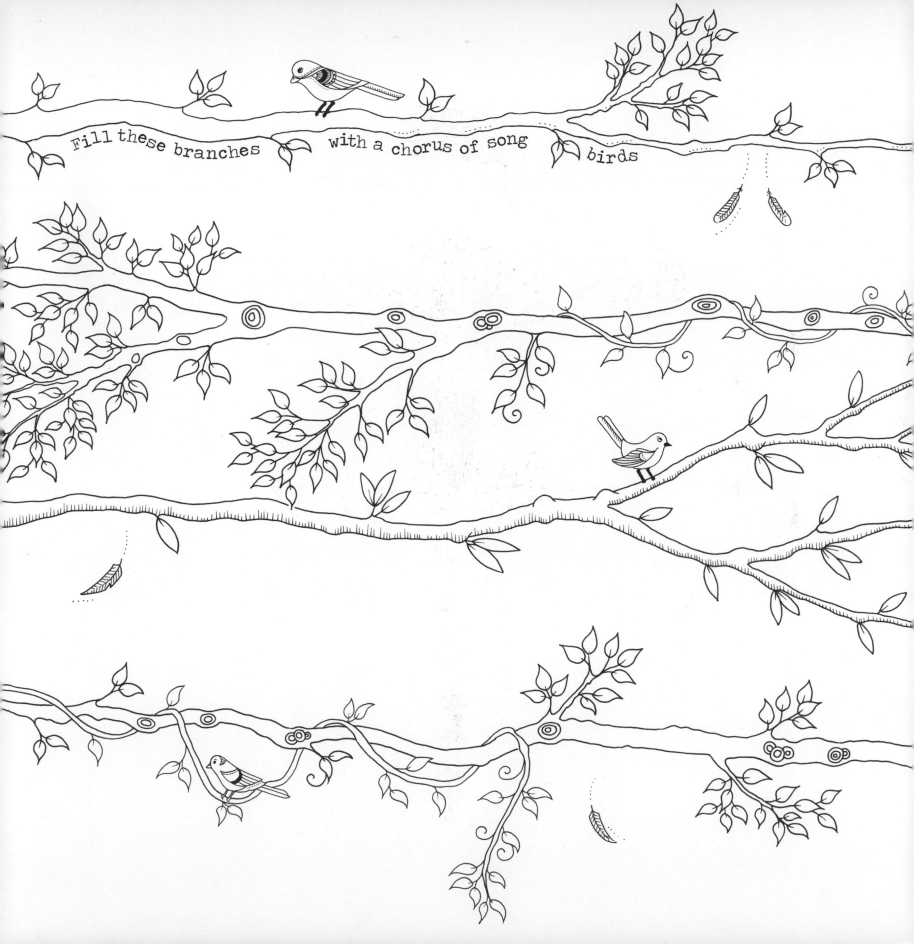

Fill these branches with a chorus of song birds

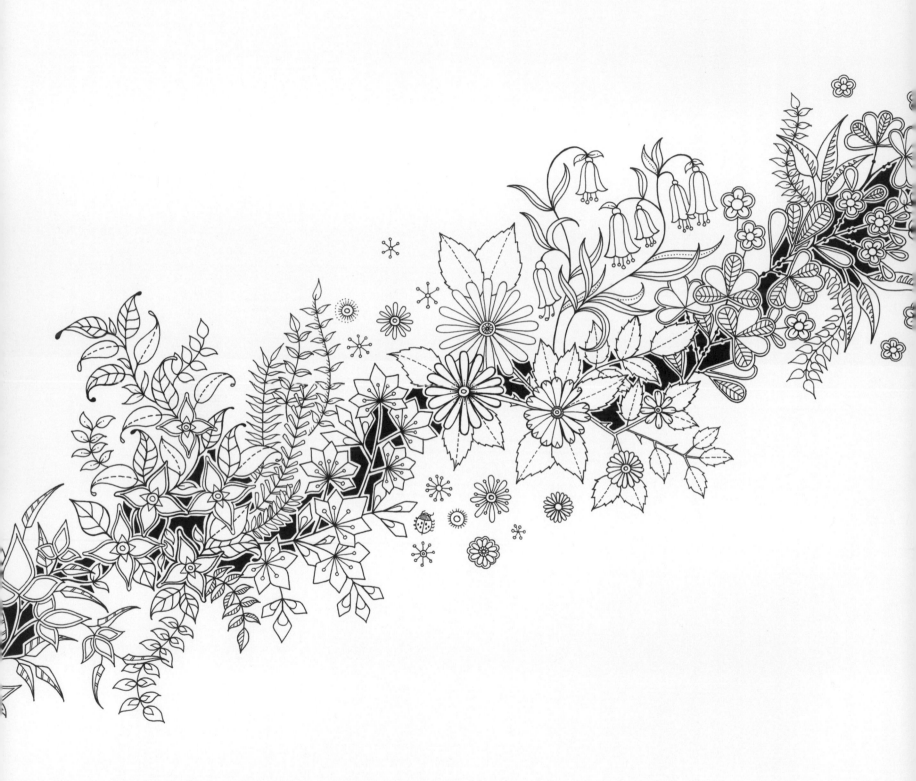

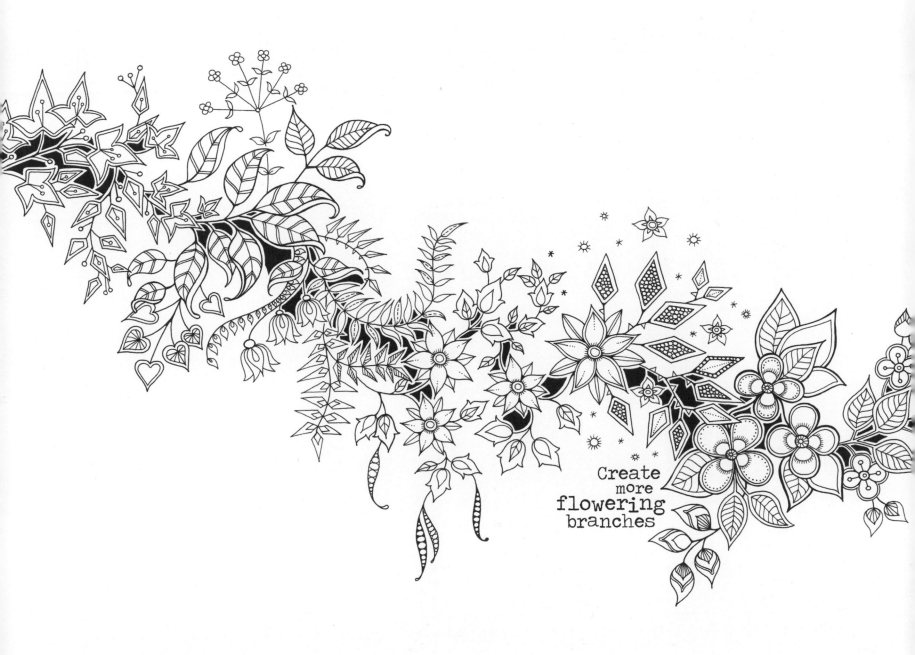

Create
more
flowering
branches

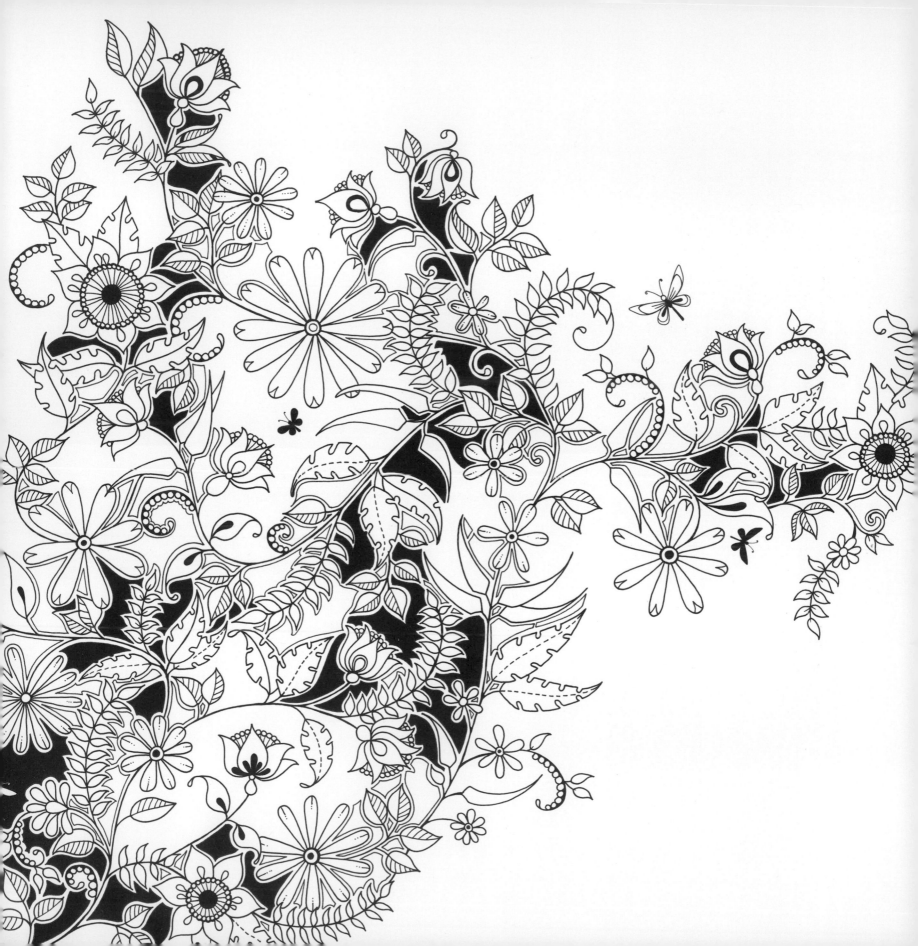

Continue
the
vine...

...and
fill
with
inky
details

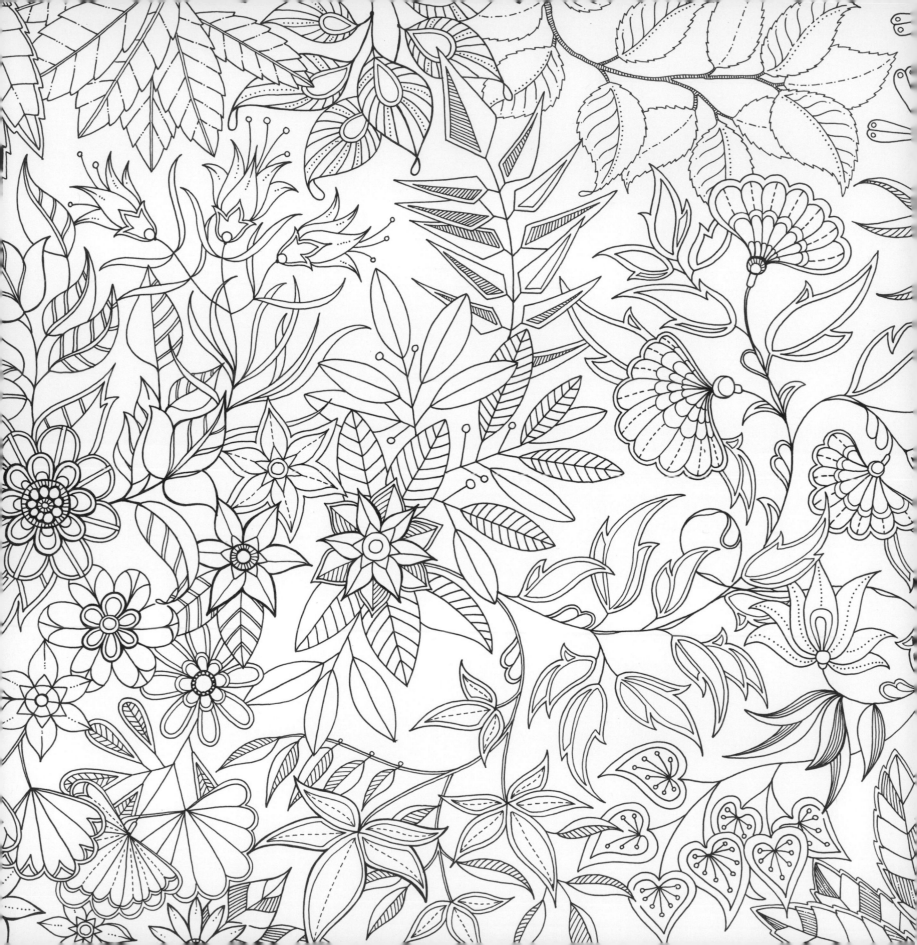

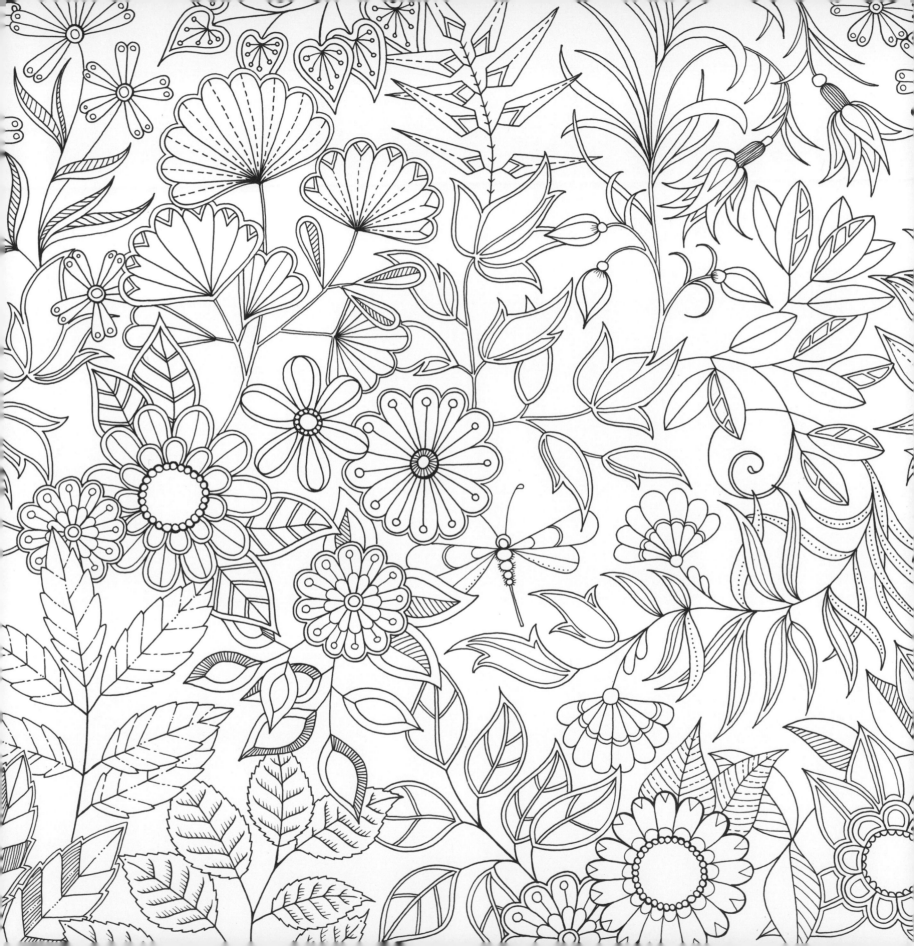

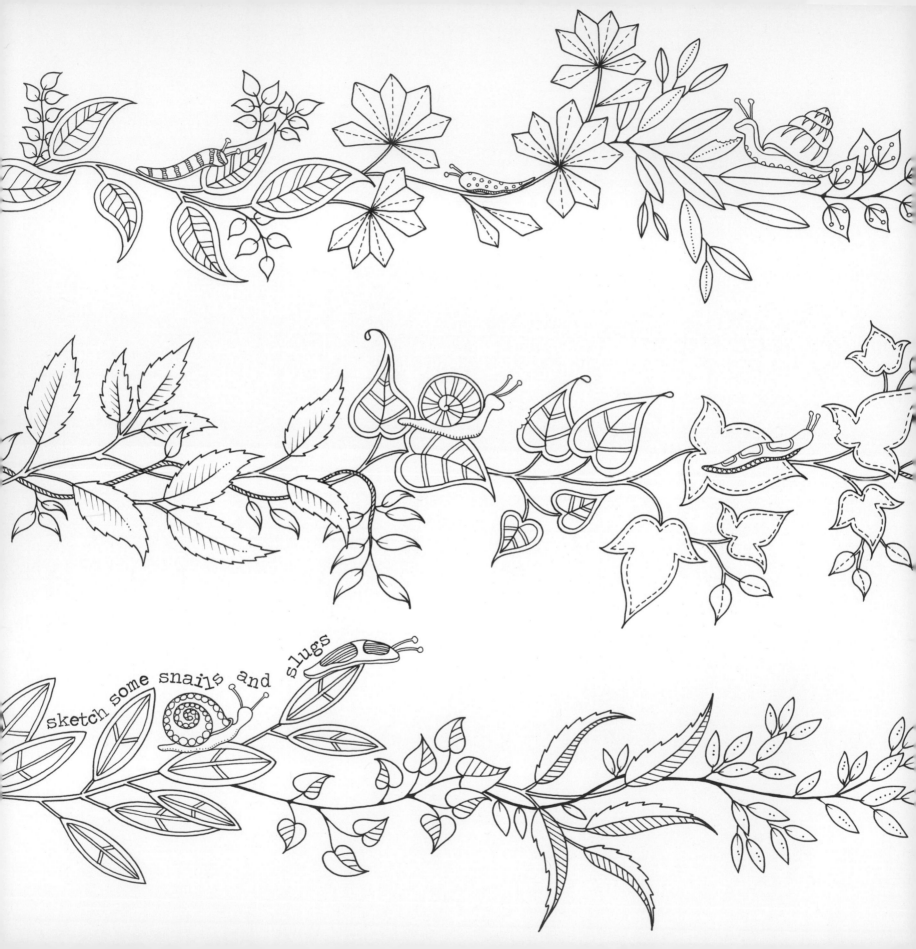

sketch some snails and slugs

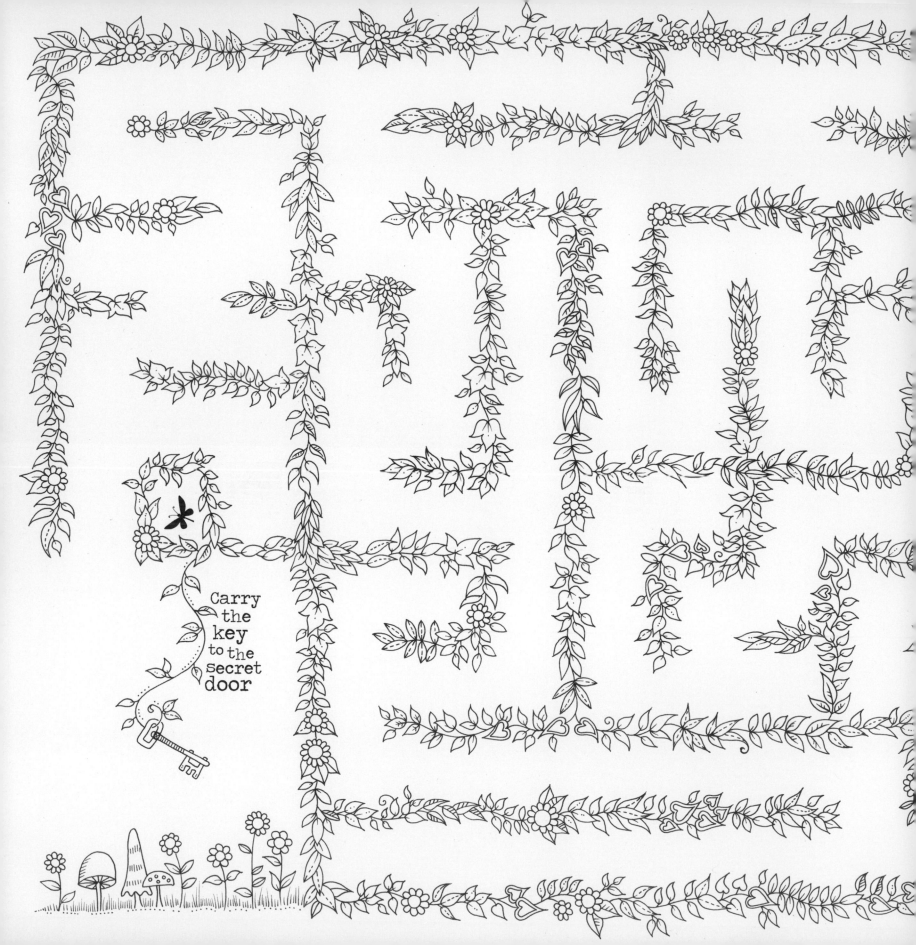

Carry
the
key
to the
secret
door

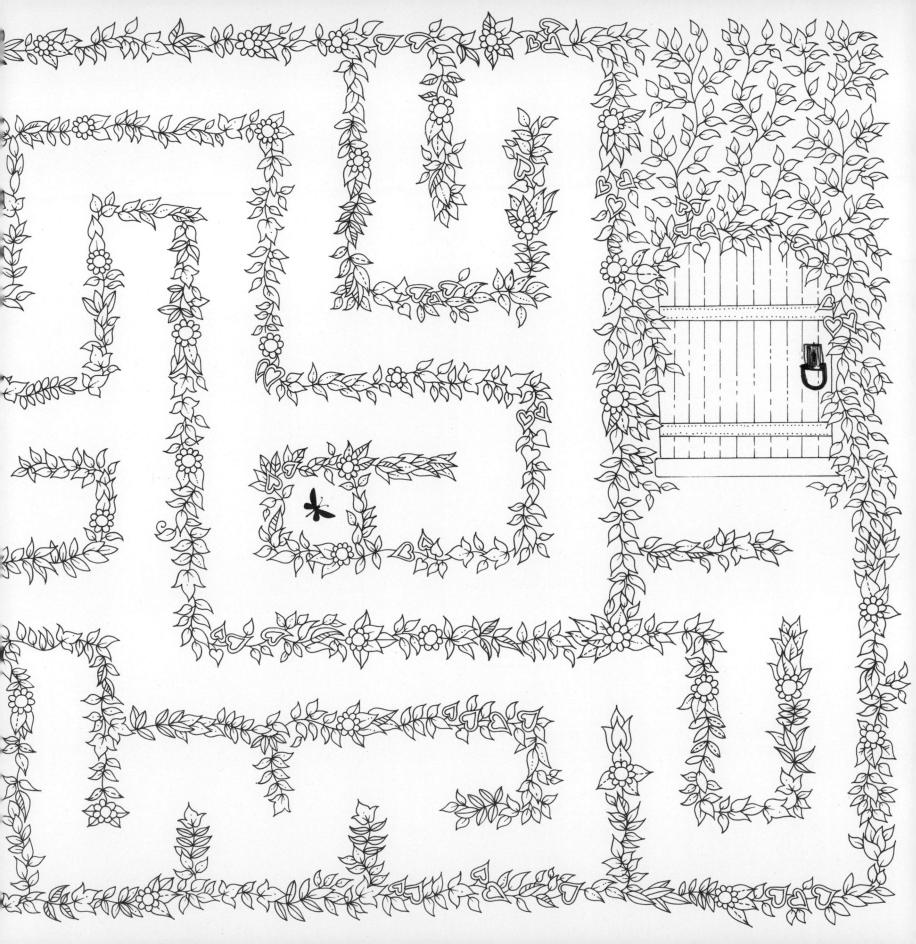

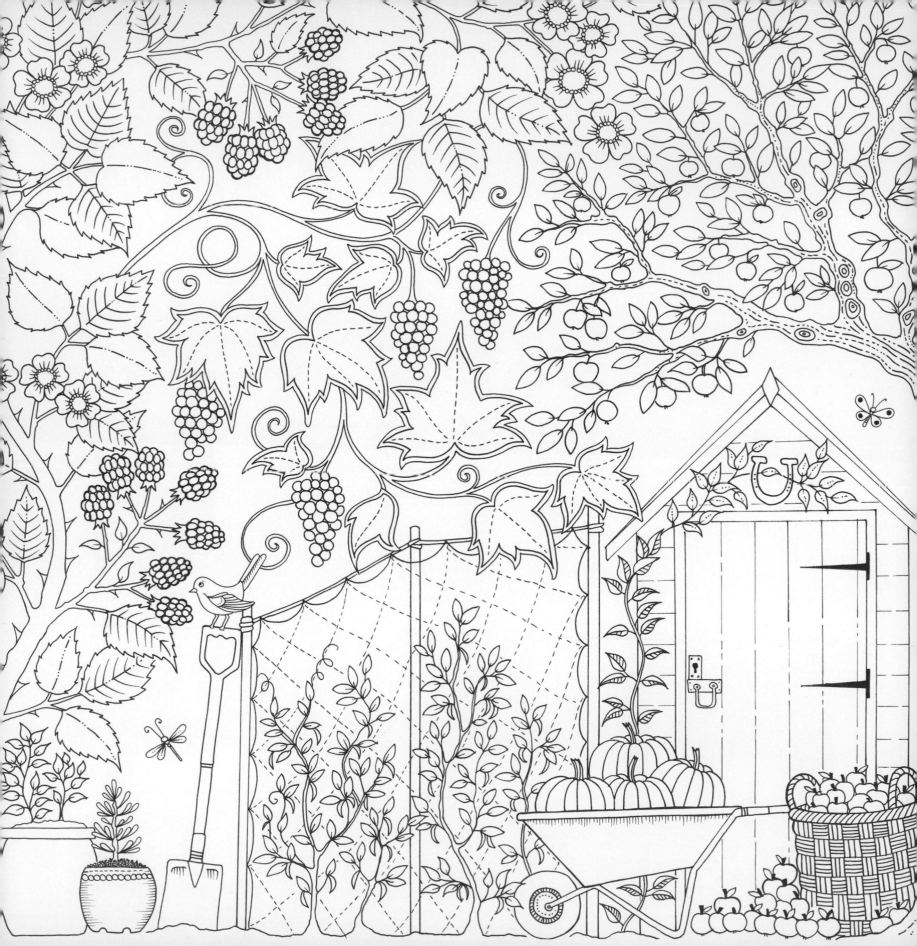

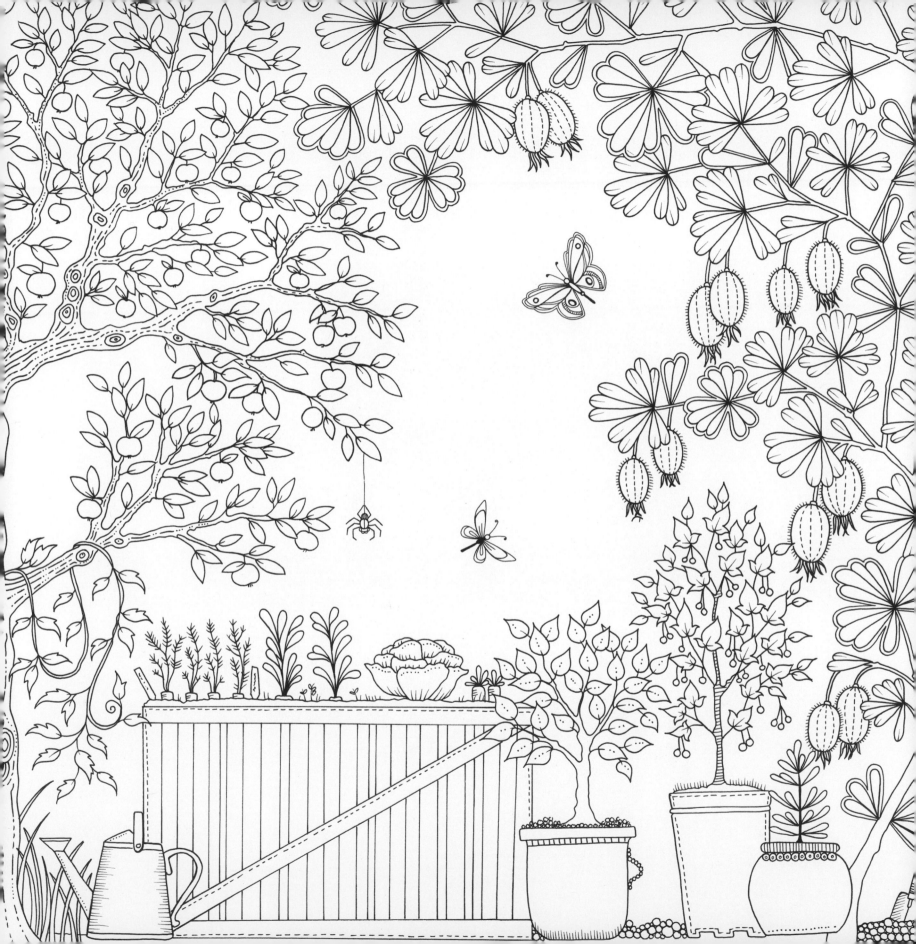

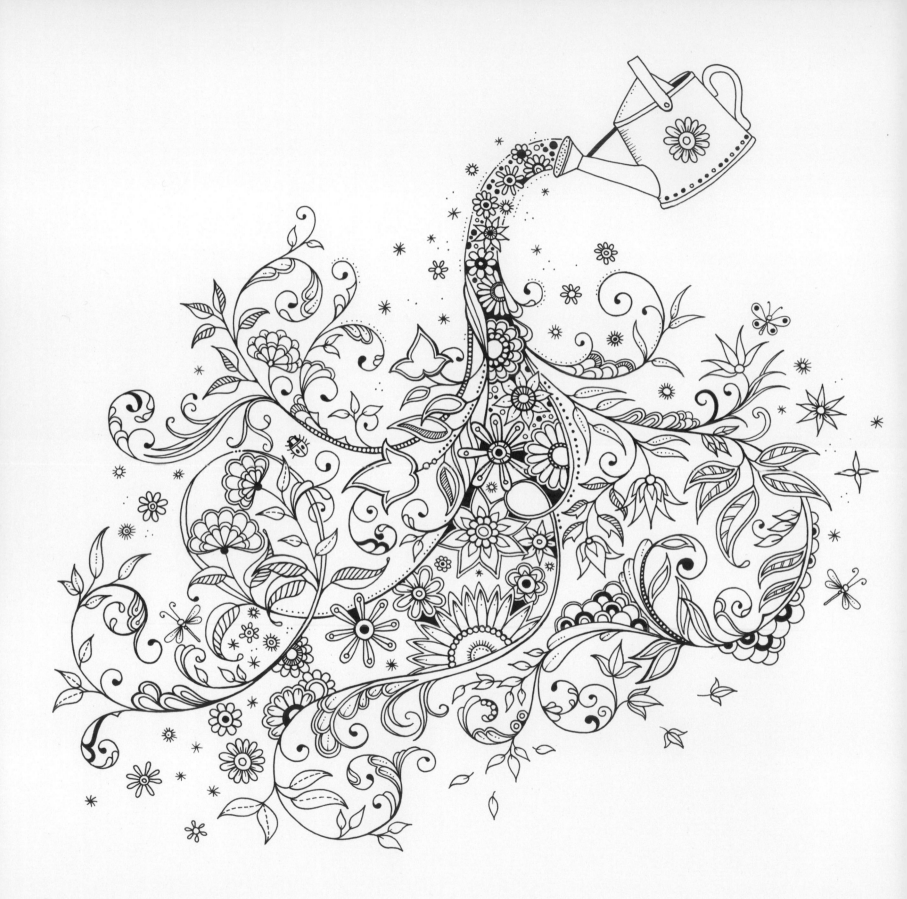

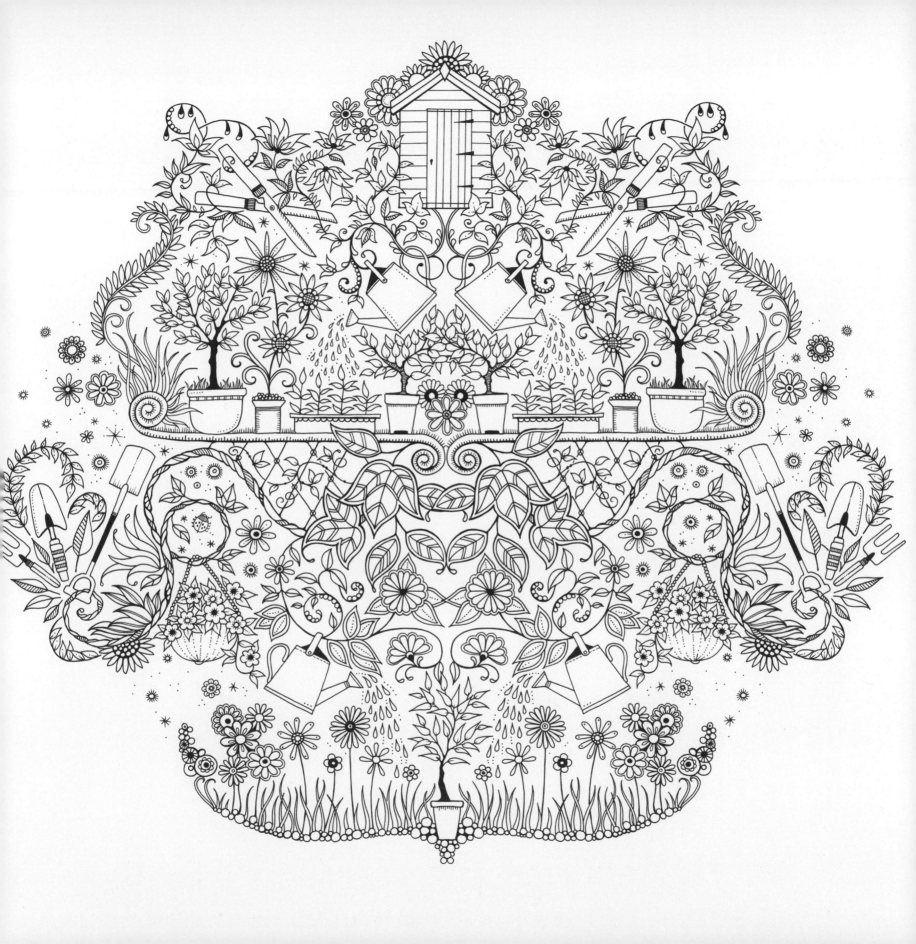

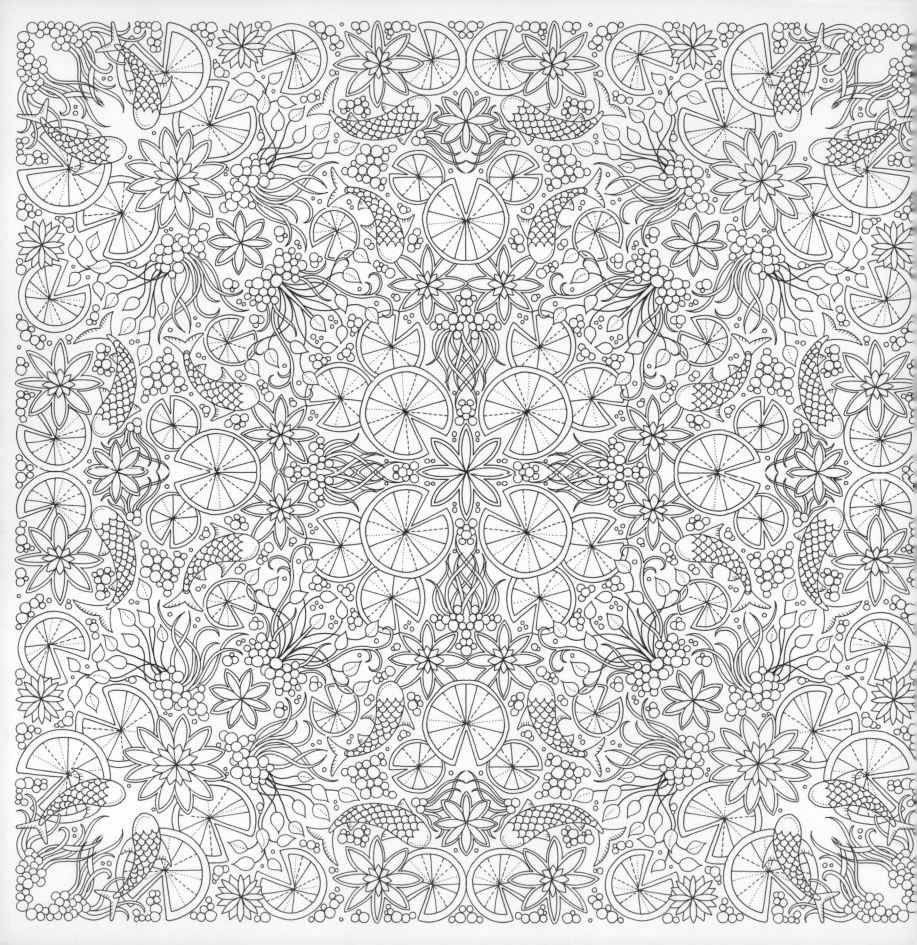

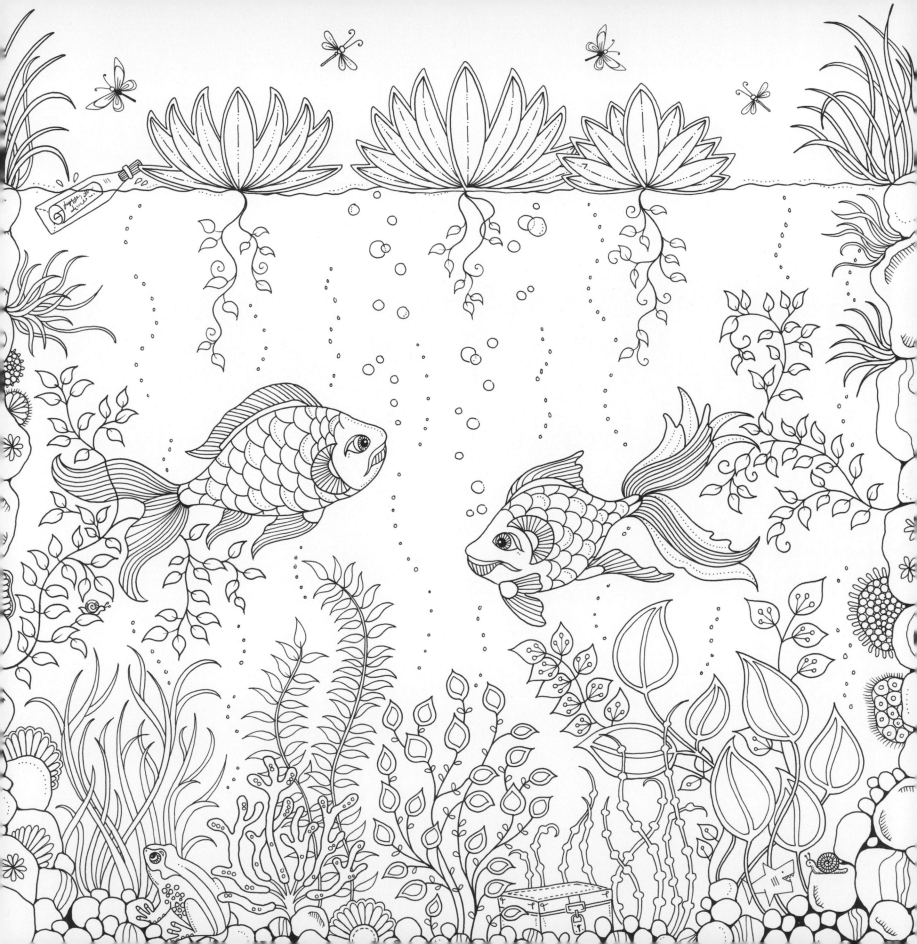

Fill the pond with fish, frogs and lilypads

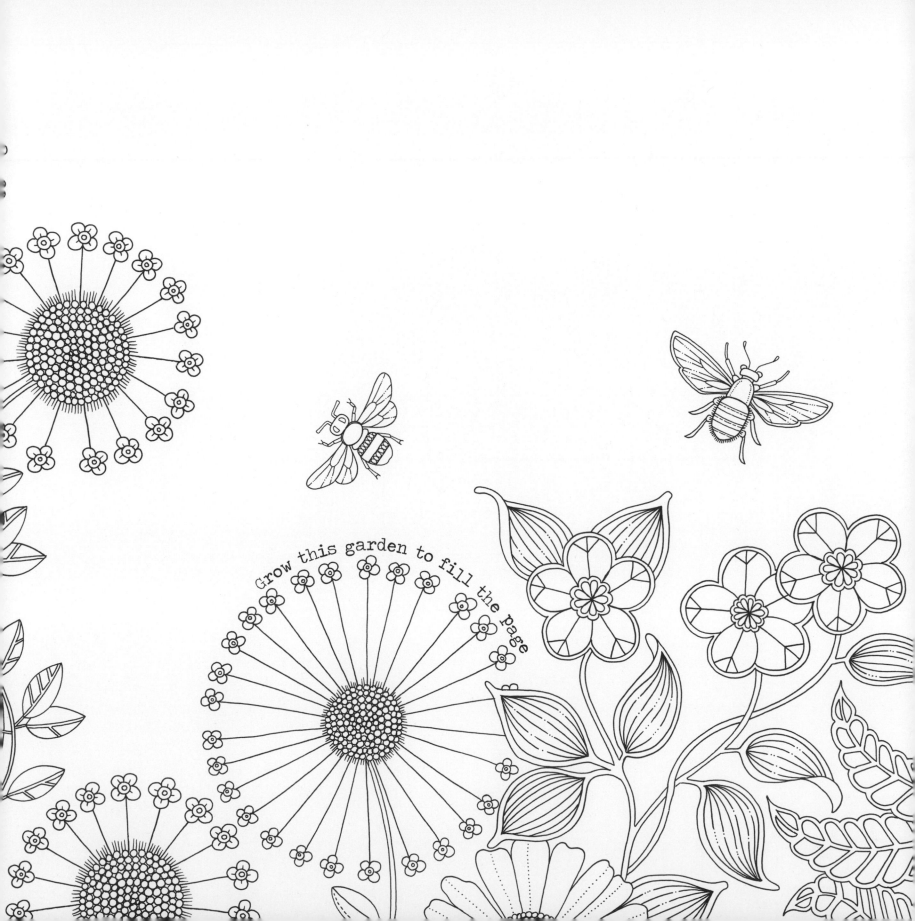

Grow this garden to fill the page

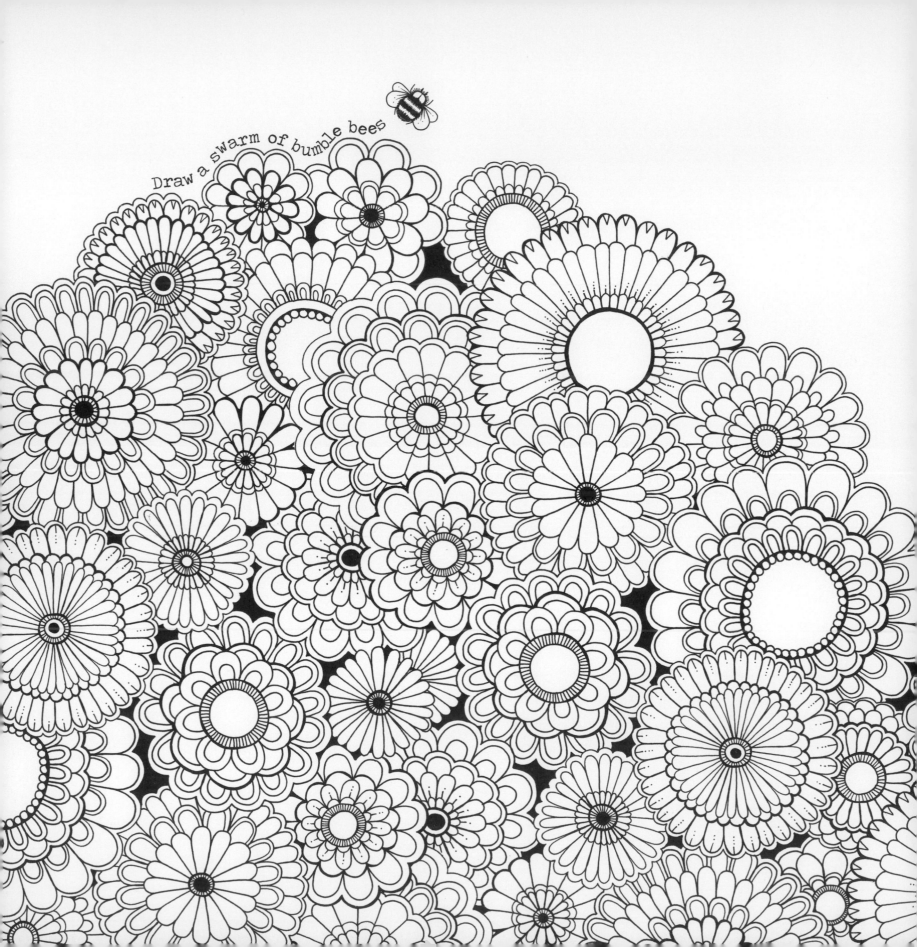

Draw a swarm of bumble bees

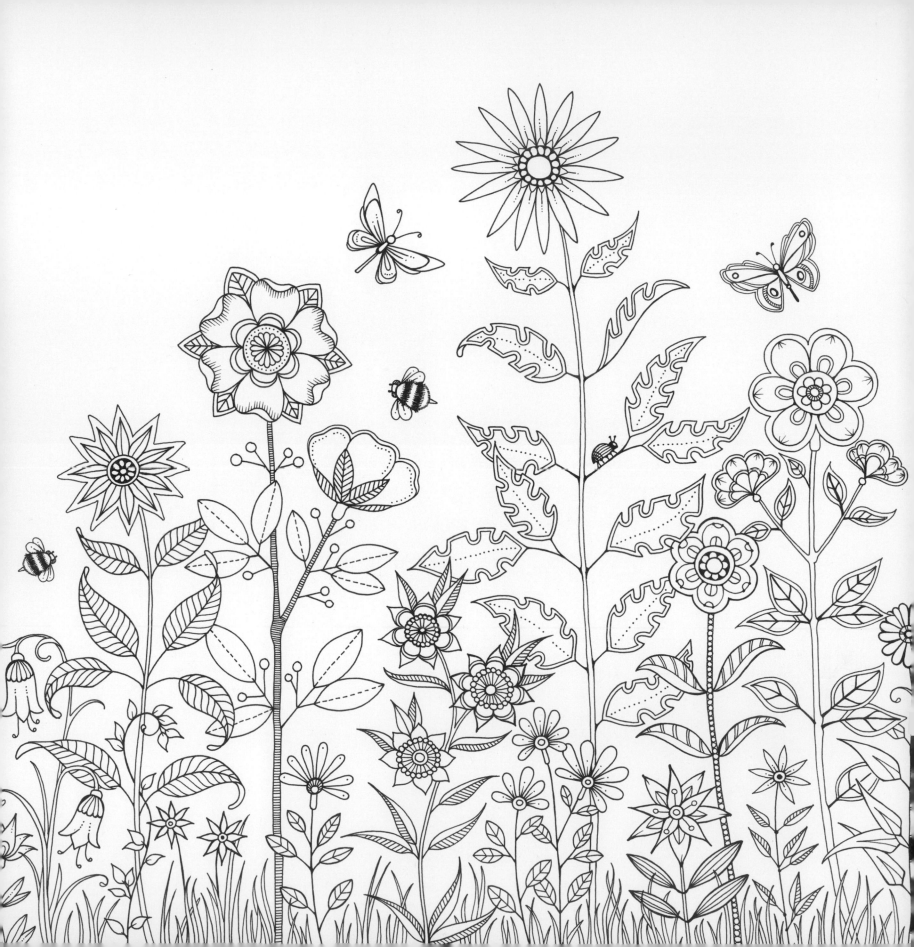

Add pretty inky petals to complete the flower garden

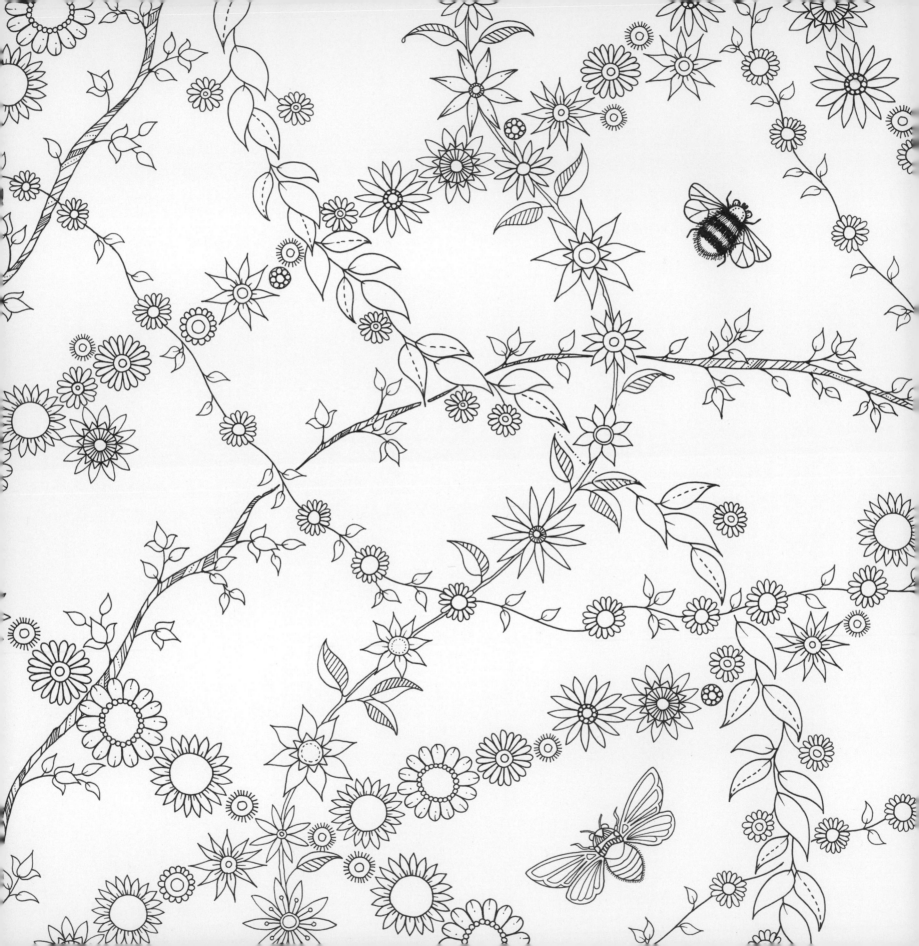

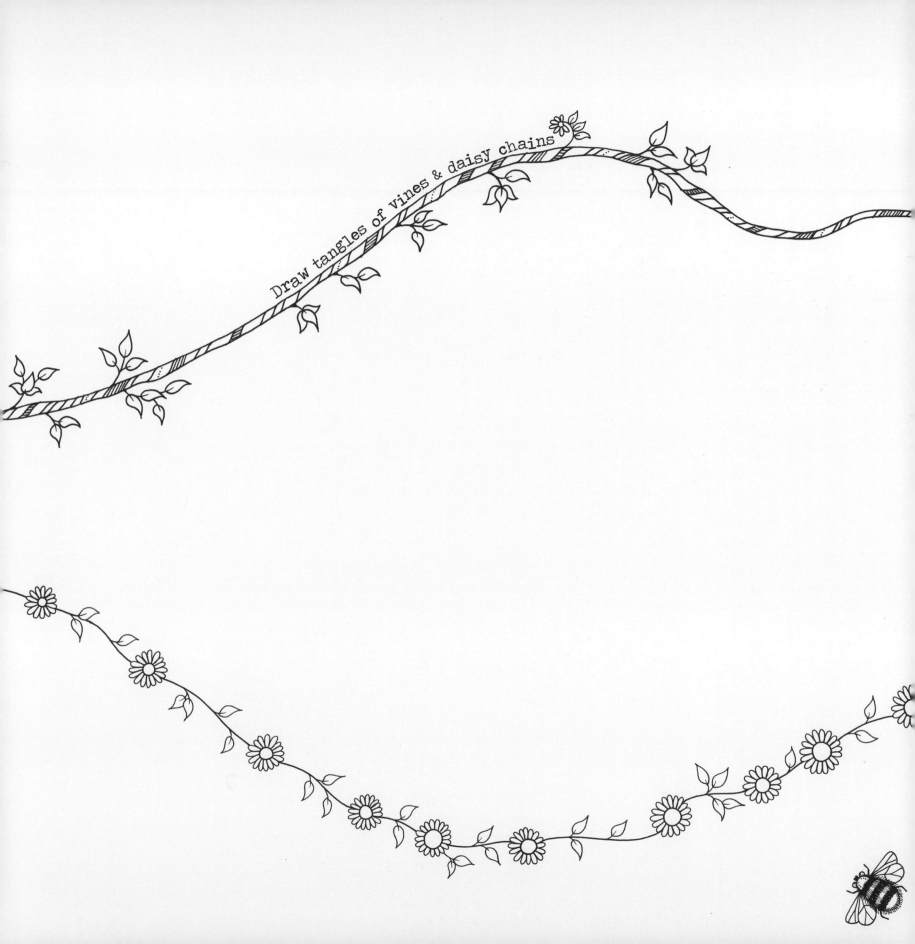

Draw tangles of vines & daisy chains

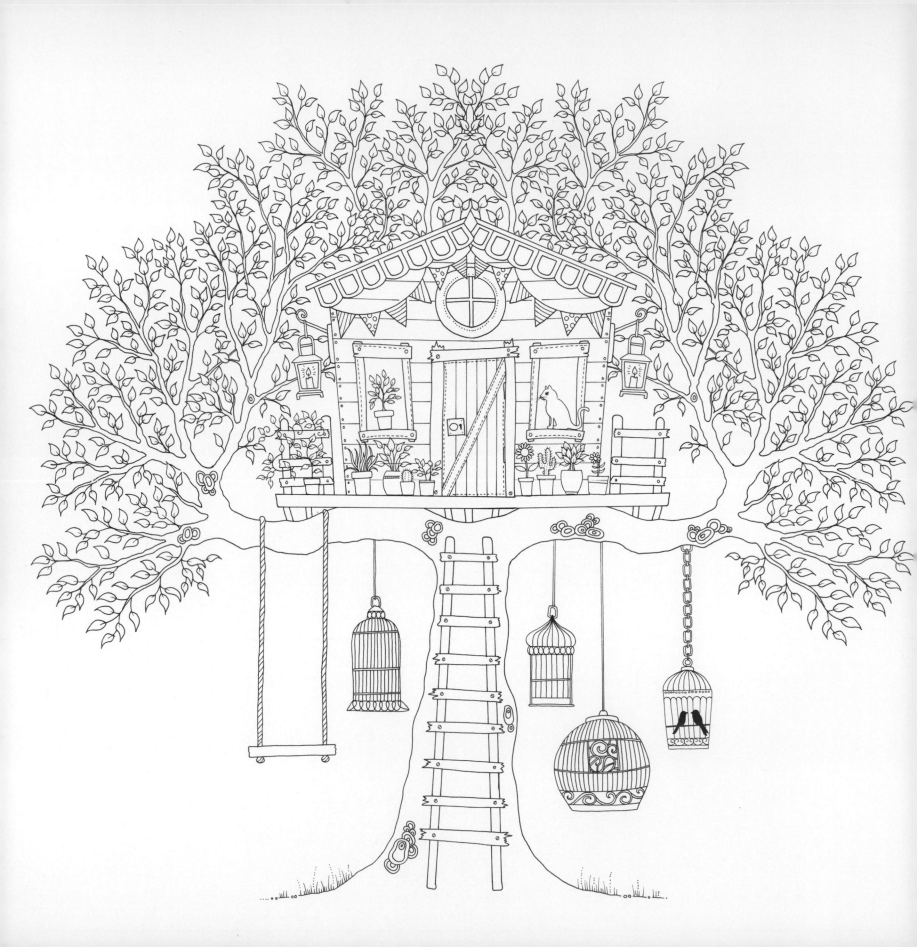

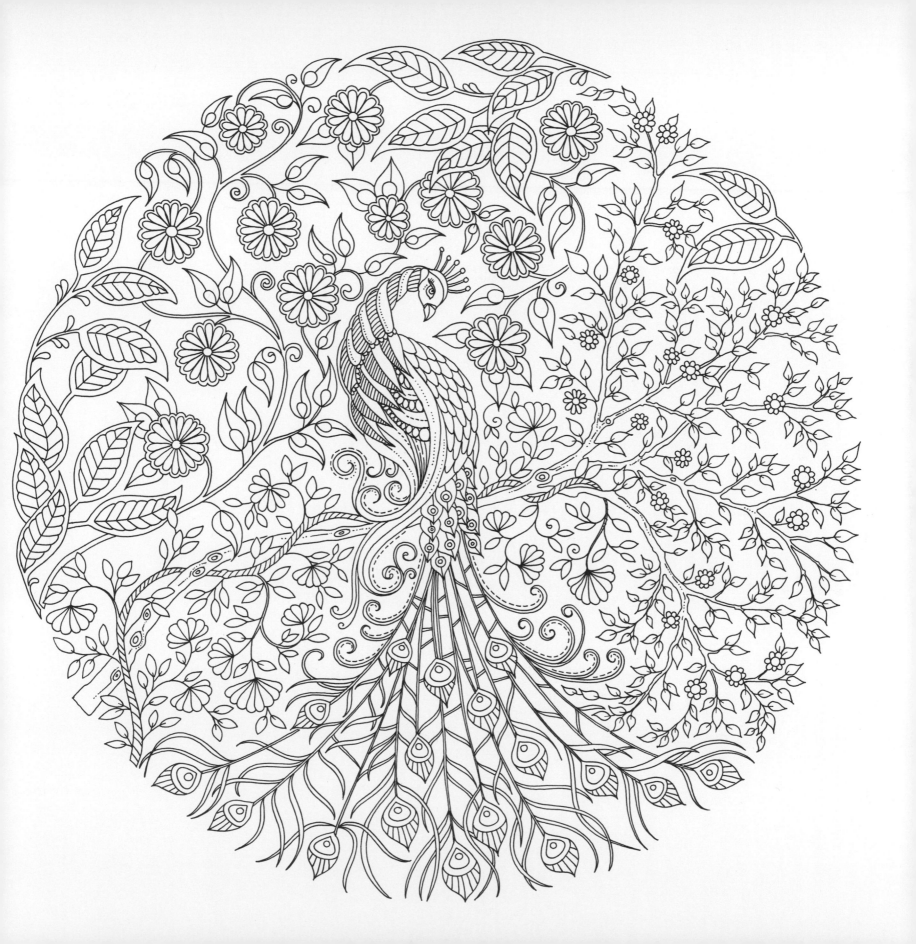

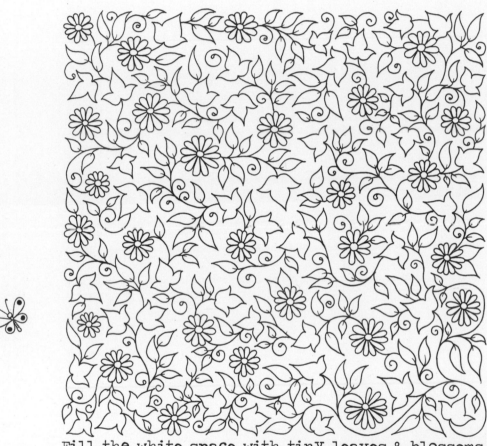

Fill the white space with tiny leaves & blossoms

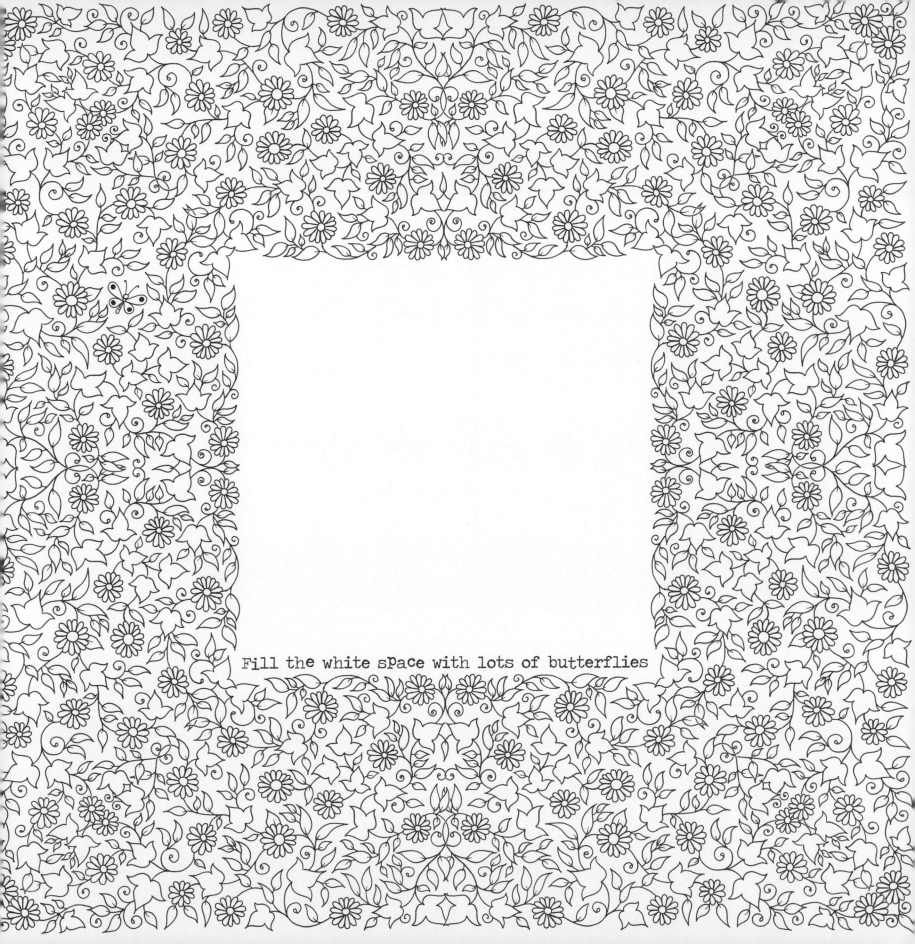

Fill the white space with lots of butterflies

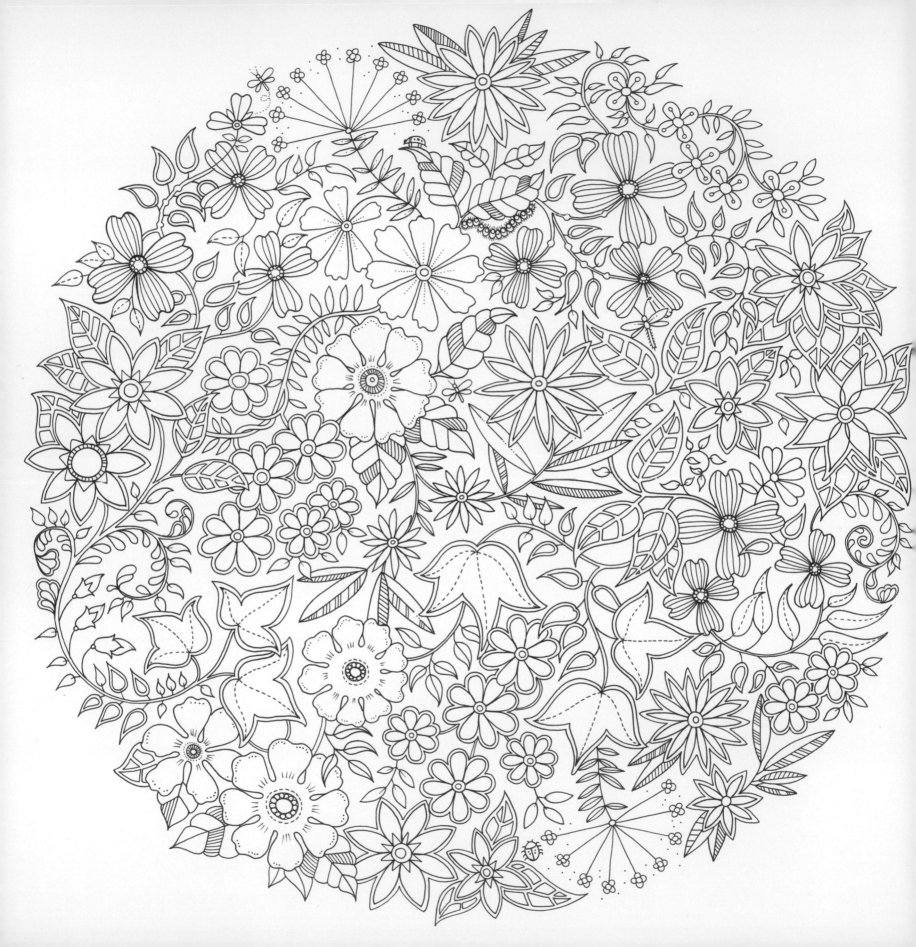

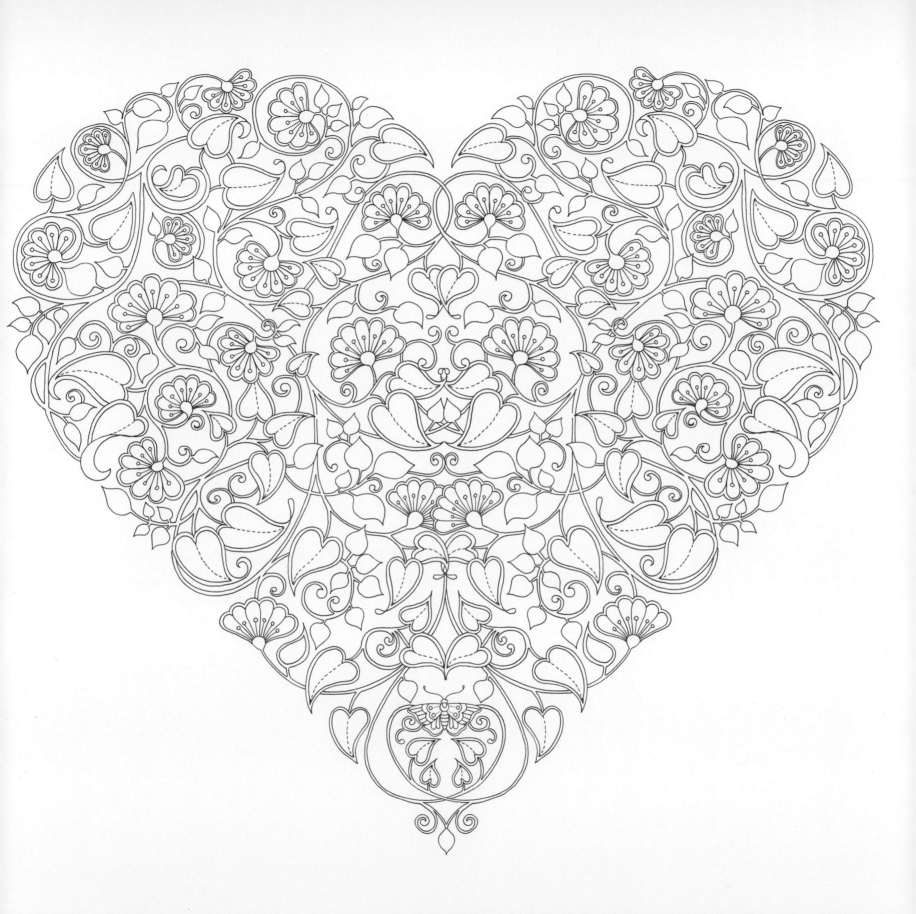

Key to the Secret Garden

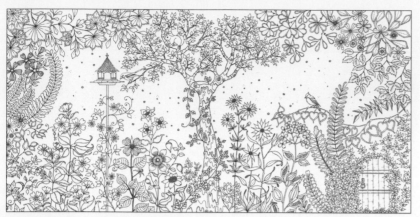

2 song birds, 1 squirrel, 1 key

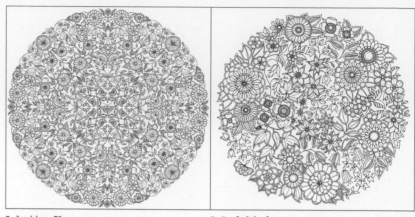

1 butterfly 1 ladybird

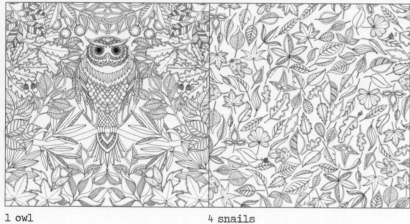

1 owl 4 snails

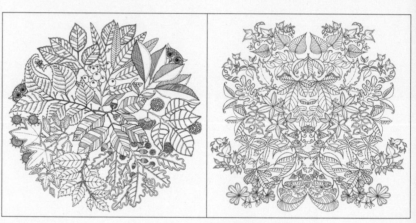

2 owls, 1 bee 6 caterpillars

4 butterflies, 3 caterpillars,
3 chrysalises

7 butterflies

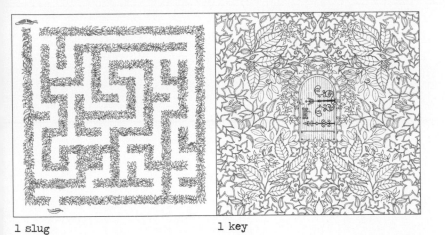

1 slug 1 key

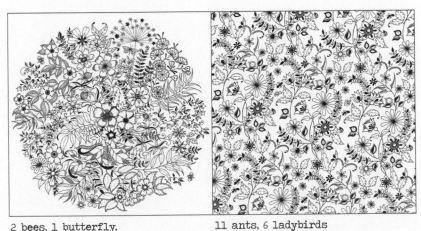

1 mouse

1 key, 1 padlock

2 bees, 1 butterfly,
1 caterpillar 11 ants, 6 ladybirds

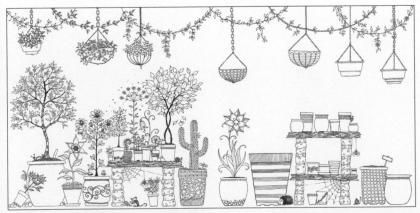

4 snails, 2 spiders, 1 caterpillar,
1 mouse, 1 hedgehog

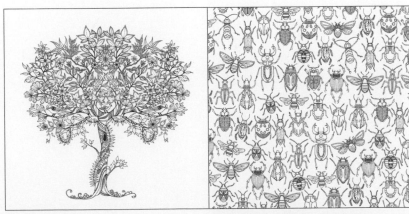
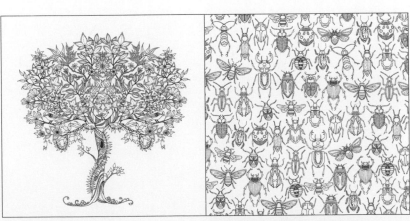

5 song birds 63 beetles, 5 flying beetles,
4 wasps, 2 moths

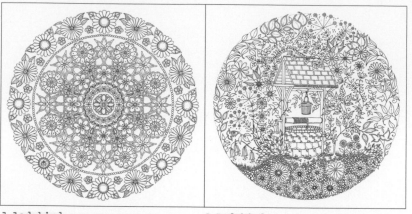

1 ladybird 1 ladybird

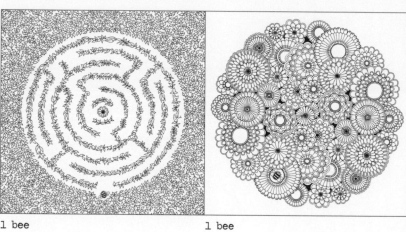

40 butterflies

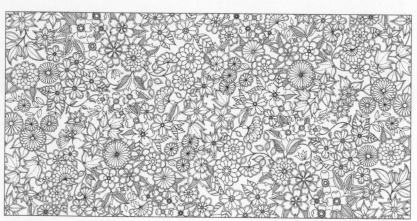

1 butterfly

1 bee 1 bee

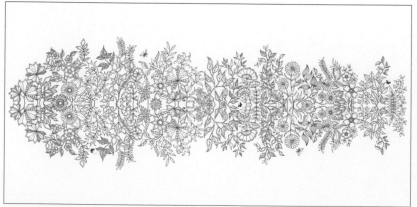

5 butterflies

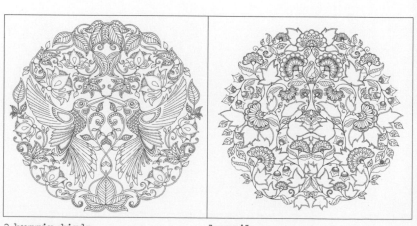

2 hummingbirds 1 snail

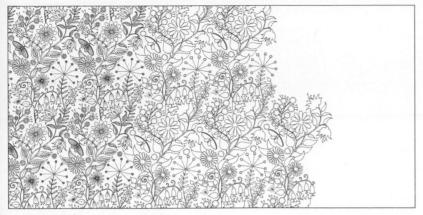

14 butterflies

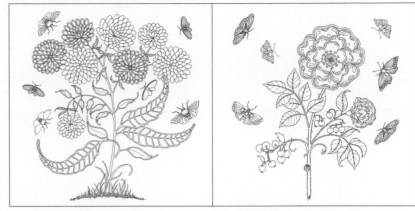

6 butterflies 6 butterflies, 1 ladybird

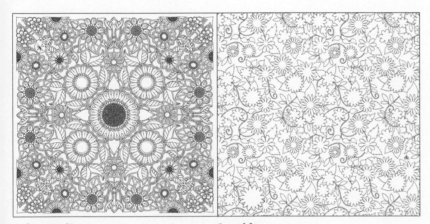

1 dragonfly 1 spider

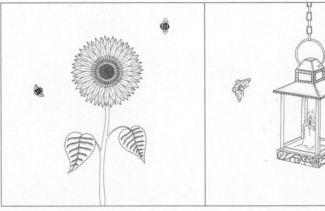

2 bees, 2 moths

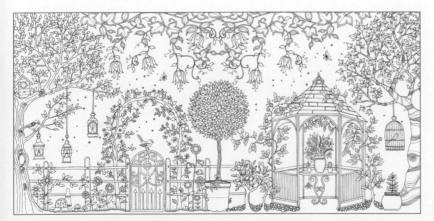

3 song birds, 2 butterflies,
1 snail

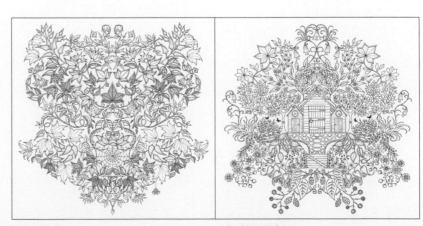

2 spiders 4 butterflies

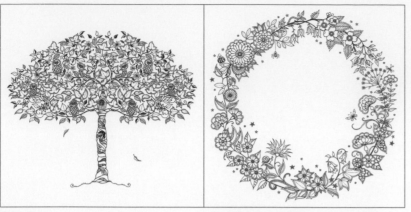

10 owls

1 butterfly, 1 dragonfly, 1 bee,
1 spider, 1 caterpillar, 1 snail

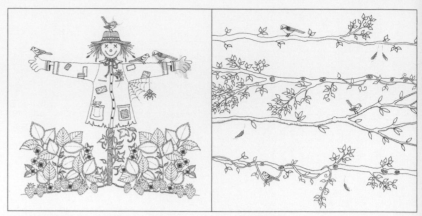

4 song birds, 1 spider, 1 mouse

3 song birds

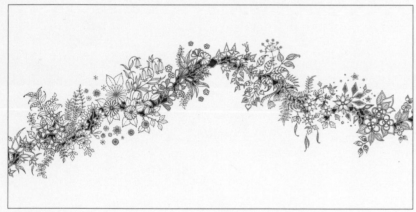

1 ladybird

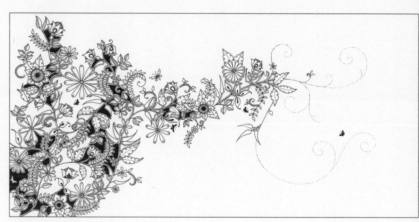

6 butterflies

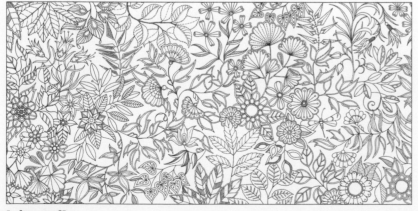

1 dragonfly

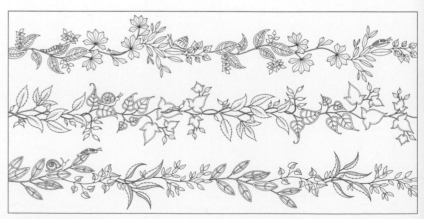

6 slugs, 3 snails

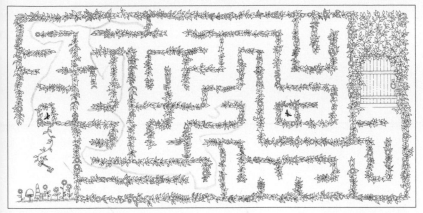

2 butterflies, 1 key

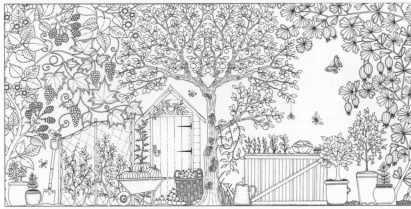

4 butterflies, 1 caterpillar,
1 dragonfly, 1 spider, 1 song bird

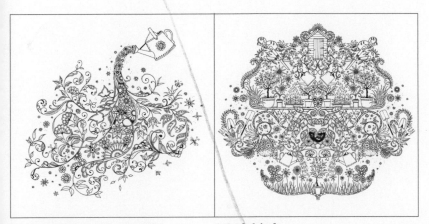

2 dragonflies, 1 butterfly,
1 ladybird

1 ladybird

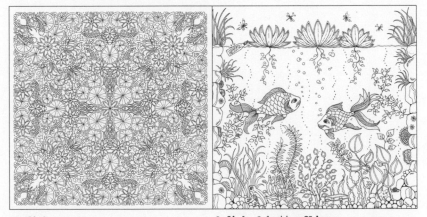

24 fish

2 fish, 2 butterflies,
2 dragonflies, 2 snails, 1 frog,
1 shark, 1 treasure chest,
1 message in a bottle

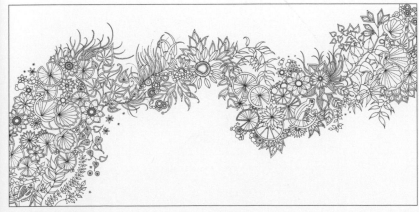

1 fish, 1 frog

1 moth, 1 wasp,
1 flying beetle

2 bees

4 butterflies, 4 bees, 1 ladybird

2 bees

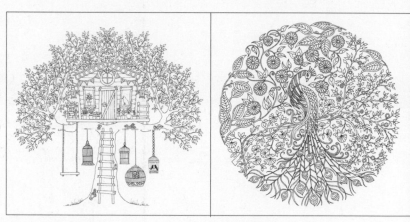

2 song birds, 1 cat 1 peacock

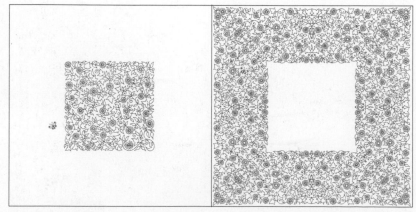

2 butterflies

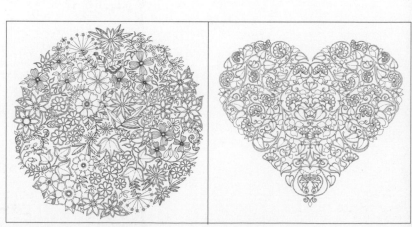

2 butterflies, 2 ladybirds, 1 butterfly
1 dragonfly, 1 caterpillar